THE UPWARD CALL

*Challenges for
Today's Christian Woman*

Pat Gempel
Editor

ILLUMINATION PUBLISHERS IP www.ipibooks.com

THE UPWARD CALL

Pat Gempel, Editor

*Challenges for
Today's Christian Woman*

Table of Contents

Section 1. Understanding God's Plan for Me

Section 2. Teaching Each Other

Section 3. Uncommon Unity

Table of Contents

Preface

Jesus' direct and uncomplicated call to his disciples is "Come follow me." Yet we realize that this challenge is the highest calling any one of us could attain-to live, think and move in this world as Jesus himself exemplified. It is a lifetime, daily commitment.

Our following Jesus. The eighteen lessons have been written by women who have exhibited victory and wisdom in the areas discussed. Hopefully, the reader will be able to personally identify with the goals, and the struggle to attain these goals, that the authors relate. Most importantly, it is our prayer that practical, solution-oriented ideas will be set into the heart of the reader, and these plans will result in specific actions that will help in the transformation of character to become more like our Lord.

Philippians 3:13b-14 reads:

"One thing I do, forgetting what lies behind and straining forward to what lies ahead, I press on toward the goal for the prize of the upward call of God in Christ Jesus."

That is our prayer for each one who reads God's word and this book. God bless you.

Acknowledgments

Our appreciation is extended to the congregations represented by the women who authored the chapters contained in this book. In alphabetical order, they are Boston Church of Christ, Boston, Massachusetts; the Central London Church of Christ, London, England; Central Park Church of Christ, Chicago, Illinois; and the Sunrise Church of Christ, Tampa, Florida.

Thank you to the editors and Illumination Publishers for the second printing of this book in 2022.

SECTION ONE

Understanding God's Plan for Me

1

The Message of the Cross and My Response

by Irene McDonnell Gifford

> *For the message of the cross is foolishness to those who are perishing, but to us who are being saved it the power of God.* (I Corinthians 1:18)

As I traveled through the cities of Europe during the spring of 1978, I can still remember staring out the train window thinking about my life. The past seven months had been difficult and lonely and full of tears. Where was I going? What was my purpose in life? Why, after years of anticipation, did this trip abroad mean so little to me? I felt unloved and unneeded-a stranger in a strange land.

It was during those bleak months in Europe that I opened the Bible and began to study about Christ. I was looking for hope, and with much anguish, I prayed to God to bring me out of the darkness and gloom I felt all around me.

I returned to New York in May and continued my search for truth and happiness. One and half years later I found the answers I sought by studying the scriptures and seeing them carried out in the lives of Christians. Even though I had been searching for a long time, my decision for Christ wasn't easy. The night before my baptism, I sat in front of a fireplace counting the costs in my

mind. I loved to do what I wanted, and I thought about how hard it would be to give up my time for God and others. I realized that my thoughts were selfish and that there was really no cost at all. Jesus had died on the cross for me so that I could know God and live with him eternally. What could be greater in this life than knowing you are at peace with God and having him continually guiding and helping you? And what a great joy and privilege it is to help others know him. I made my commitment to God and was baptized in Boston on November 18, 1979.

2 Corinthians 5:18–19 reads: *"All this is from God, who reconciled the world to himself through Christ and gave us the message of reconciliation: That God was reconciling the world to himself through Christ, not counting men's sins against them. And he has committed to us the message of reconciliation."*

Why did Jesus have to die? Hebrews 9:22 explains that without the shedding of blood there is no forgiveness. That was the plan God had made and implemented throughout the Old Testament. If Jesus hadn't died, we would have to die because of our sin, but Jesus took our place and died once for all (1 Peter 3:18). Christ lived a sinless life and became sin for us, thus breaking down the barrier between man and God caused by sin (2 Corinthians 5:21). Each of us has been given a choice about how to respond to Christ's death on the cross; it is our individual responsibility. Several of those possible responses will now be discussed: 1) submitting to God's will, 2) suffering for his name and 3) being saved through his grace.

Submitting to God's Will

While growing up, I saw paintings of Jesus on the cross but didn't think too much about them. At that time his death had little meaning for me. I took for granted the pain he went through and was ignorant of the fact that Jesus didn't want to go to the cross. Matthew 26:36-46 shows the true picture. Christ spent the night before his crucifixion in the garden of Gethsemane with his

disciples. He was deeply troubled and took his closest friends, Peter, James, and John, with him to pray. He fell with his face to the ground and prayed, *"My Father, if it is possible, may this cup be taken from me. Yet not as I will, but as your will be done."* Jesus did not want to die. His prayer expressed the anguish he felt. His emotions fought against his mind, saying "No, I don't want to do this!" But He didn't allow his emotions to control his actions. Struggling with God to somehow change the situation, he yet humbled himself completely and said, "Yet not as I will, but as you will."

That passage shows the humanity and strength of Christ. He was alone. Even his closest friends had failed him when he needed them most, but he still did not give up. He prayed a second time. *"My Father, if it is not possible for this cup to be taken away unless I drink it, may your will be done."* Notice the change in his request. Through struggling with God in prayer, Jesus learned obedience. After his third prayer, he said to his disciples, *"Rise, let us go! Here comes my betrayer!"* His need for and reliance upon God were clearly demonstrated.

Christ's example shows us that we too can become submissive to God if we are willing to take the time to struggle in prayer. I have seen how that process works in my own life. During my difficult months in Europe, I had studied French language and literature. When I became a Christian, I hoped God would use my language skills and my love for France. In August of 1981, I decided to become part of the mission team to Paris, France. Initially I was very excited about my decision, but later I began to be afraid of moving to a foreign country and leaving the friends and church I had grown to love so much. After every missions meeting I would cry and pray to God to change his will so that I could not go.

It was through those hours of prayer that God helped me submit to his will. I had to reflect upon how God had blessed me in every struggle and sacrifice. Last summer I spent two

weeks in Paris, an experience that God used to give me vision for my life there. I became friends with a few French people who I have been corresponding and building friendships with since. That has brought me much joy and given me a ministry in Paris even before I move! I am looking forward to the challenge ahead because I know God will do great things in that beautiful city.

Not only does God help us to submit to him through prayer, but he also works through other people around us. By being open with our needs and thoughts, God can use others to help us deal with our struggles. In the garden, Jesus was open with his disciples and told them how he felt. *"My soul is overwhelmed with sorrow to the point of death."*

Stay here and keep watch with me," he said in Matthew 26:38. Jesus did not allow pride to prevent him from voicing his deepest emotions. He **verbally** appealed to his disciples for their support. They deserted him. He did God's will anyway.

Communicating personal needs is an area in my life that is changing because of Christ's example. I used to expect others to be aware of my needs and feelings without my telling them. Of course, people were not always sensitive, so I was hurt when my needs were not met. God used a close friend to tell me I wasn't open about my feelings, and I should change to become so. That was hard to do. I have always had a difficult time getting close to people and being a friend. Learning how to communicate my thoughts with others was a struggle. Yet in time I forced myself to be open, learning how from my Christian friends around me. Today it is becoming a strength.

Having close friends that know and love me is now a great joy in my life. Recently I was struggling with a sin in my life that I shared with a few of my close friends. God used them to encourage me to be more serious about it. They gave me hope and vision that I could overcome. I have come to view the times of weakness and need in my life as opportunities to draw closer to God and instruct others in Christlike ways of handling problems.

Open and trusting relationships have been essential in helping me to have Jesus' attitude of submission to God.

Suffering For His Name

Paul's response to the cross was one of wholehearted devotion. Before his encounter with Christ, Paul was a very zealous Jew, known for persecuting Christians. From the outset of his conversion, he became the one who was severely persecuted. In prison for preaching the gospel of Christ, he wrote a letter to the church at Philippi, teaching them and us today that his first priority was to know Christ.

Philippians 3:7–8 reads: *"But whatever was to my profit I now consider loss for the sake of Christ. What is more, I now consider everything a loss compared to the surpassing greatness of knowing Christ Jesus my LORD, for whose sake I have lost all things."*

Why did Paul consider everything a loss compared to the surpassing greatness of knowing Christ? He appreciated being forgiven of his sins and embraced the new life Christ offered him without looking back. He understood the message of the cross.

Throughout his Christian life, Paul constantly endured all kinds of hardships, beatings, sleepless nights, and persecutions (2 Corinthians 6:3-13). Yet through all of that, his attitude remained positive, a great challenge for me. Two years ago, I became very close to three friends and studied the Bible with them. One after the other, each decided they didn't want to obey God. That really hurt. I felt like I had been personally rejected, and it robbed me of my joy. But I prayed and prayed, and God blessed me with new friends who did want to learn about God. Through my suffering for my friends, I could relate to the suffering that Jesus and Paul experienced when their friends rejected God's teaching. Christ's suffering on our behalf is the most significant act of love ever expressed. Paul realized that love and loved Jesus' back by being willing to suffer for him.

Philippians 3: 10–11 states: *"I want to know Christ and the power of his resurrection and the fellowship of sharing in his sufferings, becoming like him in his death, and so somehow, to attain to the resurrection from the dead."*

Paul desired the fellowship of sharing in Christ's sufferings. Can you make that statement? Very few of us want to suffer. But Paul wanted to know every aspect of Christ, including his suffering. Paul regarded suffering as a positive thing rather than considering it negative as most of us do.

When I think of suffering for the name of Christ, I think of agonizing in prayer over those close to me. I often spend late nights praying for others because my relationships are a major concern in my life. One sister and I had a difficult time in our relationship. She resented me for telling her the things in her life that needed to change. The tension grew to where I didn't want to help her anymore or even be near her. Once we both decided to open up and deal with our sins, things began to change. Today that sister is one of my closest friends. But it took suffering. Sometimes those around me don't appreciate the time and effort I give them and that hurts, often making me feel alone. But I realized that is suffering for his name and is nothing compared to the suffering Jesus went through for me.

What kind of attitude should we have toward suffering? Like Paul, we should be thankful to bear the name of Chris. When we envision Christ on the cross or Paul being stoned, all our complaining and problems become minor. Jesus never uttered one word of complaint. How discouraging it is to see Christian's mope around in self-pity and grumble about their hardships. We need to look at our sufferings as opportunities to grow and learn the next lesson we need to learn from God. In Romans 3:3-5, Paul explains that we can *"rejoice in our sufferings, because we know that suffering produces perseverance; perseverance, character; and character, hope. And hope does not disappoint us,*

because God has poured out his love into our hearts by the Holy Spirit, whom he has given us."

Saved Through His Grace

At Golgotha, Jesus hung on the cross between two thieves. One believed Jesus had the power to save and the other did not. Though both deserved to die, the first thief was saved through his faith in Christ. He recognized his need for God, saw himself as he really was and rebuked the other criminal for his insult. *"Don't you fear God, "he said, "since you are under the same sentence? We are punished justly, for we are getting what our deeds deserve. But this man has done nothing wrong"* (Luke 23:40-41). The thief acknowledges the authority of Christ and initiated with him, saying, *"Jesus, remember me when you come into your kingdom, "Jesus replied, "I tell you the truth, today you will be with me I paradise"* (Luke 23:42-43). Reconciliation with God is based on his grace. The thief knew he deserved death, but Christ saved him by grace. Ephesians 2:8–9 teaches us that *"it is by grace you have been saved, through faith—and this not from yourselves, it is the gift of God—not by works, so that no one can boast."* There is a direct relationship between our faith and our salvation. The thief would not have been saved had he not shown his faith.

On earth, Christ had the power to forgive sins. After his death and resurrection, a person receives forgiveness of sin by coming into contact with Christ's blood through the waters of baptism, a participation in his death, burial, and resurrection through our faith. *"We are therefore buried with him through baptism into death in order that, just as Christ was raised from the dead through the glory of the Father, we too may live a new life"* (Romans 6:4). The key to dying to our old life and being raised as a new creation is our faith in the power of God to help us change to be like Christ for the rest of our lives (Colossians 2:12).

One of the most rewarding aspects of my Christian life is seeing the changes God brings about within me. Before I was a Christian, I was very insecure and didn't like myself. Lacking inner peace and confidence, I poured my time into developing my talents so that I might make myself worth something. This created a great deal of anxiety within me because I was never satisfied with myself. God has since blessed me tremendously in that area. I am no longer anxious and jumpy, but calm and confident. It is exciting to be able to look people in the eye when I talk to them and to know I have something to give them. I attribute those changes to God's power working in my life through his Word, prayer, and the relationships he has given me in the church.

Once we are in a right relationship with God, it is our responsibility to maintain and nurture that special relationship. Understanding the message of love Jesus expressed in his death on the cross will draw us to him and motivate us to strive to please him (2 Corinthians 5:14). When we come into the light at baptism, we are completely cleansed from sin. Unfortunately, we do sin again. Does that mean we go back into the darkness? No, not if we are still striving to please God. I John 1:7 teaches that *"if we walk in the light, as he is in the light, we have fellowship with one another, and the blood of Jesus, his Son, purifies us from every sin."* By continually walking in the light, we can be continually washed by Christ's blood. How comforting and amazing that is! But to keep walking in the light, we need to keep confessing our sins to God and to one another (James 5:16). I can overcome them faster, and it encourages me to know they are praying for me.

The security of knowing we have eternal life brings peace and confidence. And God wants us to be confident women, secure in his love (1 John 5:13). He has a special plan for each one of us and sees us for what we can become through knowing

him. He is patient with our shortcomings but wants us to push ourselves to be great for him. We must always remember that it is by his grace that we can grow and change and have purpose in our lives.

For me, there is no greater joy than seeing someone I've poured my life into come to know God and then, in turn, teach someone else. That is the message of reconciliation.

We have looked at Jesus in the garden, struggling with God to do God's will, Paul rejoicing in his sufferings for Jesus' name; and the thief on the cross, being saved by God's grace. Each of those men understood the message of the cross and its meaning of reconciliation for all men. What is your response?

2

Repentance: A Way of Life

by Lynne Green and Sue Anderson

The way we live our lives involves many factors, most of which we experienced daily in the routines of life. As we explore how to make repentance not only a part of those routines but an indispensable part of our characters, we must first consider what repentance is and why we should practice it
.

What Is Repentance?

Acts 26:20 is perhaps the best definition in the Bible of what repentance involves: *"First to those in Damascus, then to those in Jerusalem and in all Judea, and to the Gentiles also, I preached that they should repent and turn to God and prove their repentance by their deeds."*

Turning to God and changing our lives is the essence of repentance. The Greek word for repent is *"metanoia."* *"Meta"* means "to change" and is the root from which *"metamorphosis"* comes. *"Noia "* refers to the mind, as in paranoia. Thus, the literal definition of *"metanoia"* is a change of mind."

Many people believe that repentance is merely feeling sorry

for something done. To the Pharisees and Sadducees, however, John the Baptist said, *"Produce fruit in keeping with repentance"* (Matthew 3:8). Partial or emotional repentance is not true Biblical repentance because God has always commanded radical change in our lives, the result of a definite change of mind. A person who has Biblically repented will show obvious changes, the kind Paul described in 2 Corinthians 7:11: and eagerness to change, alarm at the consequences, a longing to be what God wants and enough concern to do it. The latter attitude is what leads us to consistent growth in the Lord, changes that will be seen in our lives. We "feel" sorry and then "change "our actions. That is repentance.

Why Should I Repent?

The motivation to repent comes from understanding its purpose in our lives. First, repentance is absolutely essential for a person to become a Christian and have his sins forgiven. Acts 2:28 clearly states that repentance is necessary for salvation. God has given man two choices in this area, repent or perish (Luke 13:3). Jesus and God want us to become more and more like Jesus for the rest of our lives. When we overcome sin in our life it brings a joy that is hard to explain.

We know we are becoming more like Him who sacrificed His life so we could be with God for eternity. He is not trying to scare us into submission but warning us that we will harm and ultimately destroy our relationship with him if we consistently sin. That is why some disciples leave God's Kingdom (the parable of the soils, Matthew 13). Learning to become like the Lord is more complicated than overcoming sin. We must learn to walk as He walked.

Matthew 10 is a very challenging scripture. So, challenging that we don't hear it preached very much. Jesus is sending the twelve apostles out to *"practice what He has taught them."* Matthew 10:37-42 reads: *"Anyone who loves his father or mother*

more than me is not worthy of me; anyone who loves his son or daughter more than me is not worthy of me; and anyone who does not take his cross and follow me is not worthy of me. Whoever finds his life will lose it, and whoever loses his life for my sake will find it. 'He who receives you receives me, and he who receives me receives the one who sent me. Anyone who receives a prophet because he is a prophet will receive a prophet's reward, and anyone who receives a righteous man because he is a righteous man will receive a righteous man's reward. And if anyone gives even a coup of cold water to one of these little ones because he is my disciple, I tell you the truth, he will certainly not lose his reward."

God, Christ and the Holy Spirit expressed love from Genesis to Revelations. How are you expressing your repentance and dedication to them?

Last summer, I went through a trying period in which I continually overslept and didn't want to be productive. I felt guilty for being lazy and didn't believe that changing my attitude would make the situation any better. I finally set my mind to overcoming my sin. True to God's promise, my renewed discipline went beyond pleasing the Lord. It also made me happy by relieving my guilty feelings and enabling me to be more like Him.

2 Corinthians 7:10 teaches that repentance leads to salvation and leaves no regret. I certainly had no regrets about being more like our Lord, being victorious in overcoming my sinful nature. When we repent and begin to live in obedience to God again, we will experience the fulfillment and joy of living the way we were created to live, to grow to be like Christ more and more.

How to Repent to Become Like Our Lord

Repentance is not a one-time decision made at conversion when we make Jesus the Lord of our future. **Repentance is a way of life.** It is a lifetime challenge for all of us. Consider the following four principles: desire, decision, discipline and determination.

Desire

What motivates an athlete nearing the end of a practice session when all his muscles are crying to stop? Desire. The will to win pushes him beyond endurance. Desire is also the force that causes us to make changes in our lives as Christians. Love for God and appreciation for His plan for us to be with Him (not Satan) for eternity (or life is a vapor in comparison) should motivate us to change anything that is displeasing to him. Titus 2:11-13 says: *"For the grace of God that brings salvation has appeared to all men. It teaches us to say 'No' to ungodliness and worldly passions, and to live self-controlled, upright and godly lives in this present age, while we wait for the blessed hope-the glorious appearing of our great God and Savior, Jesus Christ."* We are anticipating our eternal life with God, Christ and the Holy Spirit.

One of the greatest challenges to any student is to consistently earn good grades. In college, I found that when my motivation to learn was strong. I could finish my homework and concentrate while I was studying. When my motivation or desire was weak, it was very difficult to study. So, too, in the Christian life, we cannot live long on legalistic motivation. (Parable of the weeds). If our heart and gratitude to God that our sins have been forgiven and desire to do God's will aren't firmly in our minds, it will be difficult to fight against our sinful nature. Satan is always tempting us with our sinful nature. What will happen? Our intense desire should be to live our lives to please God by becoming more and more like Christ, our perfect example.

Our desire is produced by seeing ourselves and the world as God does. 2 Timothy 3:1-5 reads: *"But mark this: There will be terrible times in the last days. People will be lovers of themselves, lovers of money, boastful, proud, abusive, disobedient to their parents, ungrateful, unholy, without love, unforgiving, slanderous, without self-control, brutal, not lovers of the good, treacherous, rash, conceited, lovers of pleasure rather than*

lovers of God-having a form of godliness but denying its power. Have nothing to do with them." How accurately does this passage describe the people of the United States today? We need to pray for the world, that God's will, will be done, and that he will allow for a place for some to worship in peace.

In 2 Samuel 12:1-7, King David, after being confronted by Nathan, saw himself as God did. This caused him to change his behavior. Psalm 51 describes his desire to be a completely different person:

> *Have mercy on me, O God,*
> > *according to your unfailing love;*
> *according to your great compassion*
> > *blot out my transgressions.*
> *Wash away all my iniquity*
> > *and cleanse me from my sin.*
> *For I know my transgressions,*
> > *and my sin is always before me.*
> *Against you, you only, have I sinned*
> > *and done what is evil in your sight;*
> *so you are right in your verdict*
> > *and justified when you judge.*
> *Surely I was sinful at birth,*
> > *sinful from the time my mother conceived me.*
> *Yet you desired faithfulness even in the womb;*
> > *you taught me wisdom in that secret place.*
> *Cleanse me with hyssop, and I will be clean;*
> > *wash me, and I will be whiter than snow.*
> *Let me hear joy and gladness;*
> > *let the bones you have crushed rejoice.*
> *Hide your face from my sins*
> > *and blot out all my iniquity.*
> *Create in me a pure heart, O God,*
> > *and renew a steadfast spirit within me.*

Do not cast me from your presence
or take your Holy Spirit from me.
Restore to me the joy of your salvation
and grant me a willing spirit, to sustain me.
Then I will teach transgressors your ways,
so that sinners will turn back to you.
Deliver me from the guilt of bloodshed, O God,
you who are God my Savior,
and my tongue will sing of your righteousness.
Open my lips, Lord,
and my mouth will declare your praise.
You do not delight in sacrifice, or I would bring it;
you do not take pleasure in burnt offerings.

Verse 17 continues:
My sacrifice, O God, is a broken spirit;
a broken and contrite heart
you, God, will not despise.

Jesus came to forgive our sins and give is all a way to gain the Holy Spirit when we decide to follow Him, are baptized, for the forgiveness of sin (Acts 2:38 and following).

Decision

We must make specific, measurable decisions and goals in order to succeed in repentance. The prodigal son in Luke 15 made concrete decisions:

1. He decided what he was going to do.
2. What he was say.

Then he implemented his decisions. We also must decide what to do and say and then make it happen. Write down precise goals. It is difficult to convert generalities into action unless they

are broken down into specifics.

In Luke 9:23, Jesus tells his disciples: *"If anyone would come after me. He must deny himself and take up his cross daily and follow me."* The Christian life is a daily walk with God and thus takes a daily decision to repent of the sin in our lives. Begin each day with the prayer, "God, I want to live this day for you," and remember that the decision to repent is a vow before God. Do not delay in fulfilling it (Ecclesiastes 5:26). How are you doing with this challenge? Ask someone that knows you well. God is all powerful and will answer your prayer.

Discipline: a characteristic of a disciple of Christ

The desire and decision to repent will take discipline to make the necessary changes in your life. It takes discipline to say "no" to dessert after dinner when one has decided to lose weight. It takes discipline to keep a dating relationship pure until marriage. It takes discipline to change out burst of anger (fits of rage).

Hebrews 12:11 reminds us that *"no discipline seems pleasant at the time, but painful. Later, however, it produces a harvest of righteousness and peace for those who have been trained by it."* That echoes a well-known saying: "no pain, no gain." Anything of value usually costs us. The price may be money, hard work, time or even sleep. But practicing a personal discipline and self-denial is crucial in changing to become more Christlike. *"Therefore, brothers, we have an obligation-but it is not to the sinful nature, to live according to it. For if you live according to the sinful nature, you will die; but if by the Spirit you put to death the misdeeds of the body, you will live, because those who are led by the Spirit of God are sons of God"* (Romans 8:12-14).

What do you think about Paul's (and God's) attitude toward discipline (discipling yourself to Christ's ways)? I Corinthians 9:24-27 says: *"Run in such a way as to get the prize. Everyone who competes in the games goes into strict training. They do it*

to get a crown that will not last; but we do it to get a crown that will last forever. Therefore, I do not run aimlessly; I do not fight like a man beating the air. No, I beat my body and make it my slave so that after I have preached to others, I myself will not be disqualified for the prize." Ask yourself: am I running to win the prize or am I just walking?

Determination

A determined person will try their best to finish a task, even when it is hard. Jesus was determined to go to the cross for us, so He could be sacrificed for our sin, and we could have eternal life with God. He allowed nothing to distract him. He was determined and not distracted by:

- People (Mark 1:36-39)
- Situations (Luke 13:31-33)
- His feeling and weakness (Matthew 26:36-46)

That kind of determination is needed to lead a victorious, repentant life. He is our perfect example in every way. I need to be aware that I will never be perfect as Jesus was, but I am trying my best to try each day to do the best I can. God is happy when we try our best.

As we try to lead a repentant life, what sort of distractions will get in our way? Family problems, financial difficulties, illness, unexpected situations, our personal desires, and goals all come to mind. I have been distracted from my personal Bible study by a phone call, either one I need to make or a call to me. In my prayer time, my mind can wander or tire. If we make goals for ourselves and are determined to reach them whatever we need to do to make it happen.

Repentance as a way of life can be a reality for you and me. It takes desire, decision, discipline, and determination. The reward will be heaven in the end. In this life we will become

confident and complete the Upward Call has given His daughters (and His sons). May God work in all of our lives to help others.

3

The Path to Discipleship

by Joyce Arthur

Who Is A Disciple?

Jesus gave us direction in Matthew 28:18-20: *"Then Jesus came to them and said, 'All authority in heaven and on earth has been given to me. Therefore, go and make disciples of all nations, baptizing them in the name of the Father and of the Son and of the Holy Spirit and teaching them to obey everything I have commanded you. And surely, I will be with you always, to the very end of the age.'"*

"Making disciples" of Jesus and *"teaching them to obey everything I (Jesus) have commanded"* is our mission. His church is made up of "disciples of Jesus." John 3:16 and 2 Corinthians 5:11-21 tells us He wants all people to be reconciled to him, because He loves us so much. He promises in Matthew 28:20 *"to be with us always, to the very end of the age."* He wants us to do his will on earth as it is done in heaven (Matthew 6:10). To spend eternity with God and other disciples we must be a disciple of Jesus. So, "What is a disciple and how does a person become a disciple of Jesus?"

Let us first understand the difference between the words, "disciple" and "Christian". The Bible teaches that disciples were first called Christian (Christ-like) at Antioch, Acts11:26. Prior to that time, everyone who had made Jesus, Lord of their life was known as a disciple of Jesus or simply, a disciple. In fact, the word "Christian" appears only three times in the New Testament. The word "disciple" appears nearly three hundred times. In virtually every case, it refers to one who follows Christ and can be used interchangeably with the word "Christian". Exceptions occur when the word "disciple" refers specifically to the twelve apostles, as in Matthew 11:1, or to the followers of John the Baptist in John 1:35. Whenever disciple is used in a general sense, however, the word "Christian" can be accurately substituted. Therefore, our title could be rephrased, "The Path to Discipleship."

With this clarification, we can think more seriously about the answer to the question, "The Path to Discipleship." A disciple of Jesus is not just a student of Jesus, a learner as some appear to believe. A disciple is one who takes on the lifestyle of the Master, Evidently, the early disciples of Jesus imitated his teaching in his as best they could. This practice caused the general populace to call them "Christians"—people who were Christlike. Discipleship is not something just learned in the mind, but something lived out in a life. It is more than learning what the teacher says, it is becoming a reproduction of the teacher As the apostle Paul stated in 1 Corinthians 11:1, *"Follow my example as I follow the example of Christ."*

We are told by people of the world today that the morals or lifestyle of a teacher have nothing to do with his effectiveness in the classroom. This is not true of the disciple of Jesus. An older woman who is unchaste and browbeats her husband at home cannot go to a Bible study and teach the younger women as she should. Consider Paul's advice to Titus on this subject in Titus 2:3-5: *"likewise, teach the older women to be reverent in the way*

they live, not to be slanderers or addicted to much wine, but to teach what is good. Then they can train the younger women to love their husbands and children, to be self-controlled and pure to be busy at home, to be kind, and to be subject to their husbands, so that no one will malign the Word of God."

A disciple is a person who is dynamic, one who grows step by step into the likeness of the Master, Jesus. Discipleship is not a static condition but an ongoing process. The one who is discipled should become a discipler. In Matthew 28:18-20, Jesus said that disciples should be made and then taught to obey everything Jesus had commanded. Thus, an endless chain is forged. Christians commit the gospel to faithful men who will teach others also (2 Timothy 2:2). A disciple disciples a person who disciples a person who disciples a person ad infinitum.

What Is The Pathway to Discipleship?

Jesus said that *"if any man would come after me, he must deny himself and take up his cross and follow me"* (Matthew 16:24). There are two stages in becoming a disciple. The first is a surrender to the lordship of Christ (a decision to commit to imitation Jesus's commitment to God), having your sins forgiven and receiving the gift of the Holy Spirit through immersion baptism (Acts 2:38ff), i.e., self-renunciation and a surrender to the lordship of Jesus. The second is following the example of Jesus and becoming like Him. The goal is for a disciple to reach maturity in Christ.

This chapter is concerned with the first stage, the one of becoming a Christian or disciple of Christ and beginning the process of discipleship. In Ephesians 2:12, people who are not disciples of Christ are described as *"without hope and without God in the world."*

Christians are commanded to "make disciples." The most effective way is to study the Bible and become friends. We need to understand one another. Sharing our life and sharing how we

found the Lord and what we went through is very effective. Also, a personal discussion with a disciple of Jesus and the Word of God are powerful life changers. Sharing how much Jesus means to me and how much God and Christ love all of us is more life changing than an impersonal tract about how to become a disciple of Jesus. That is God's way.

How Does A Person Become A Disciple of Jesus

God's Word provides us with the only acceptable answer to this question. The process of becoming a disciple of Jesus Christ is illustrated in every example of conversion in the book of Acts. The Ethiopian eunuch (Acts 8:26–35), an important government official and a deeply religious man, is one the simplest and clearest examples of conversion. God responded to this man's efforts to seek the truth by sending Philip the evangelist to guide him in his search for God.

The opening scene of the story shows the eunuch riding along in his chariot and reading Isaiah 53:7–8, while on his way home from worshipping in Jerusalem. Philip approached the chariot and asked the eunuch if he understood what he was reading. The Ethiopian then invited Philip to get into the chariot and explain the scripture. Philip used the Isaiah passage, which prophesied the coming of Jesus and his ministry, as a text for preaching about Jesus. After hearing Philip's message, the eunuch requested baptism and Philip baptized him, the eunuch thus became a disciple of Jesus. Evidently, the eunuch himself became a discipler as Christianity soon took root in Ethiopia and began to grow.

As we read other accounts of conversion in the book of Acts, it becomes clear that the gospel was taught, open hearts accepted it as true, and people turned from living for themselves to serving Jesus as the Lord of their lives. They gladly proclaimed their faith in him, completing their obedience by being born again of water and the Spirit (Acts 2:38–41). They became disciples who

in turn became disciplers.

A more detailed study of the conversion process reveals five essential concepts to be grasped and implemented if one is to become a disciple. God has given us all the information we need regarding how to be saved, i.e. become a disciple, 2 Peter 2:3. Each person must hear the Word; believe it and develop a faith and trust in God; repent by turning to God and making Jesus the Lord of his life; publicly confess Jesus as Lord and the Son of God' and be immersed in water for the forgiveness of his sins, the consummation of the new birth. The Holy Spirit will then be given to the new Christian who has now become a disciple of Christ and a new creation. As we explore those concepts one by one, please remember that we must be obedient to all of God's teachings, 2 Timothy 3:16,17.

1. **Hear.** We must first hear the message before we can respond to it. That basic fact is clearly expressed in Romans 10:14—*"How then can they believe in the one of whom they have not heard? And how can they hear without someone preaching to them"?* Verse 17 describes the result of hearing: *"Consequently, faith comes from hearing the message, and the message is heard through the work of Christ."* We can conclude that there are two major ways to hear about God: through reading his Word on our own and by having someone teach it to us. For instance, we can be taught by attending church or a group Bible study and by personally reading the Bible with a friend. The outcome of hearing is the development of our faith, which brings us to the second element.

2. **Believe.** The most important requirement in becoming a disciple is our faith. After hearing God's Word, we must come to firmly believe it. Everything we do from this point on will stem from our belief or faith. We

have heard and we must believe that *"God so loved the world that he gave his one and only Son, that whoever believes in him shall not perish but have eternal life"* (John 3:16). Eternal life cannot be attained without believing that Jesus is the Son of God and that he was sent into the world for us.

3. **Repent.** One indication of a saving faith is a willingness to repent. We know that sin separates us from God and that if we die in our sins, we will be eternally separated (Isaiah 59:1–2). Therefore, we must learn how to repent of our sinful ways. In Greek, the work "repent" means "to turn". The Bible teaches us that if we are to be saved by God, we must continually change to be like Christ. This includes eliminating negative behavior from our lives. (sin=actions Christ never had) and adding positive traits personified in Jesus, such as love, joy, peace, patience, and self-control.

 Repentance is essential for forgiveness by God. Luke 13:3–5 twice states that *"unless you repent, you too will all perish."* That is a reasonable requirement, in our day-to-day lives, we do not expect our friends or families to forgive our wrongs until we repent and change our actions. In a similar way, God expects repentance that is proven by deeds (Acts 26:20). Does that mean we are saved at the point of repentance? No. 2 Corinthians 7:8–11 describes Biblical repentance and verse 10 states the *"godly sorrow bring repentance that leads to salvation and leaves no regret."* Repentance, then, is necessary for salvation but is not the only requirement.

4. **Confess.** If we are truly living in faith, we will be willing to confess Jesus as Lord. Others need to know that we are going to live a life like Christ's. Romans 10:9

teaches *"that if you confess with your mouth, 'Jesus is Lord,' and believe in your heart God raised him from the dead, you will be saved."* Here we see that an outward confession as well as an inward belief are prerequisites to our salvation. Hearing and believing, however, are not optional. 2 Timothy 2:19 states that *"everyone who confesses the name of the Lord must turn away from wickedness."* Confession and repentance are specifically and essentially linked together.

5. **Be Baptized.** Another natural response to a living faith is the willingness to obey God in baptism. Acts 2:36–42, describes a group of people who have just come to a complete faith in Jesus Christ. They have realized that he is the Son of God and that their sins were responsible for putting Christ on the cross. Their spontaneous response was: *"When the people heard this, they were cut to the heart and said to Peter and the other apostles, 'Brothers, what shall we do?'"* That is a powerful example of living faith. The people believed so strongly that Jesus died for them that they wanted to respond to him, *"Peter replied, 'Repent and be baptized everyone of you in the name of Jesus Christ, so that your sins may be forgiven, and you will receive the gift of the Holy Spirit.'"* Again, we find the command to repent of sins. In addition, the people are instructed to be baptized for the forgiveness of their sins and to receive god's spirit. Baptism is the point at which our sins are forgiven, a crucial step in conversion since it is sin that keeps us separated from God.

How does this work? Why does going down in a pool of water result in the forgiveness of our sins? Romans 6:2–4 illustrates what happens during baptism. We are sharing in the death, burial and resurrection

of Jesus Christ. We are dying to our sins, repenting, and burying them in the waters of baptism where God washes them away (Acts 22:16). We are beginning a new life. We have truly acted out of obedience and now are in a right relationship with God, free from our past slavery to sin.

When our sins are forgiven, we receive God's spirit which gives us the power to change and become like Christ. Water baptism consummates the new birth. Said another way, it was God's plan and the beginning of our submission to Him. He doesn't need to explain why He did it this way, we just need to obey.

Why Shouldn't I Become A Disciple of Jesus?

Now look back at the Ethiopian eunuch in Acts 8:36. At this point, he knows what is necessary to become a disciple and is ready to decide. His question, "Why shouldn't I be baptized"?, is a common and very important question. Everyone should stop and think about the costs and benefits involved in this crucial decision and weigh them prior to deciding.

A thorough cost analysis is recorded in Luke 14:25-27. *"Large crowds were traveling with Jesus, and turning to them, he said, 'If anyone comes after me and does not hate his father and mother, his wife and children, his brothers and sisters-yes, even his own life-he cannot be my disciples. And anyone who does not carry his cross and follow me cannot be my disciple.'"* Jesus here spoke of things we must understand before becoming disciples. We must be willing to put God first in our lives, before our families, our friends and even ourselves (sometimes the most difficult of all). Matthew 10:37–38, makes the same statement, telling us that we can't love anyone more than God.

Christ did not give us those commands to make our family relationships suffer. My own experiences have proven o me that his commands improve those relationships. Before I became a

disciple, my family and I were not close, and I feel primarily responsible for the separation between my mother and me. After I decided to put God first in my life, I started to see things drastically change with my mother. I followed God's Word in loving and respecting her, accepting her life and efforts, and showing my appreciation to her with supporting words and actions. Now I enjoy a very special and meaningful relationship with my mother because of my devotion and obedience to God. I have seen this also change my relationship with my husband, sisters, and brothers as I grow in my life as a Christian. Putting God first can make us improve all areas of our lives, especially as we strive to die to our own will and put God's will into action. Before we can become disciples, we must be willing to make Jesus the Lord of every area of our lives.

Luke 14:28–30 further explains why we must consider these things before we can be Christians. Jesus used the illustration of a man building a tower. If the man does not estimate the cost of the project before he begins it, he may find that he cannot complete the project and would consequently lead onlookers to ridicule him, saying, *"This fellow began to build and was not able to finish."* Before beginning to build our lives as Christians, we also need to consider as much as possible of what will be involved. When individuals start without committing to grow and continue for the rest of their lives to follow the Lord, they are leaving God. Leaving God is serious and hurts the individual and the church (Hebrew 6:4–6, 2 Peter 2:20–22). God is able to keep us strong if we pray and try.

Why Should I Become A Disciple?

With all those costs in mind, why would anyone want to become a Christian? The Ethiopian eunuch, knowing the price he had to pay, still decided to commit his life to God, believed that Christ was God's son, committed his future to God and was quickly baptized for the forgiveness of his sin and to receive the

gift of the Holy Spirit to guide his future. He enthusiastically began his life as a disciple of Jesus? Why?

How else do you have your sins forgiven, receive God's Spirit to help you live the rest of your life on earth and have eternal life in the presence of God, Christ, the Holy Spirit in the presence of perfect love, joy and peace? How else do you escape the influence of Satan and the demons? How else do you escape eternity with pain and agony with Satan? Will there be trouble in this life. Yes. Your troubles will help you grow in your faith if you pray and call on God for answers. John 6:60–69 describes a time when it was getting difficult to follow Christ, and many people began turning away from him. Verses 67–69 record Peter's conclusion: *"Lord, to whom shall we go? You have the words of eternal life. We believe and know that you are the Holy One of God."* Peter reasoned that though it may be hard to follow Jesus at times, the benefit of eternity with God far surpasses the benefits of anything else. With that reasoned conclusion, one won't need any more persuasion to follow Christ. God is love. Without God we are lost.

One last verse that is an encouragement for us to follow the Lord. John 10:10 where Jesus promised *"I have come that they may have life and have it to the full."* My life as a Christian is fuller than any other life I could have chosen. Notice the Ethiopian's attitude after obeying God's command to commit his life to Christ and be baptized-he went on his way rejoicing (Acts 8:39).

Summary

We have looked at many verses from God's Word that enable us to answer the question we began with: "What is the path to discipleship?" God has made an answer possible through his perfect plan for each of us to become a disciple and then go on to help those near and dear to us to have the same opportunity. The question, "How Can I?" was answered by outlining the five essential elements of conversion: hearing the Word, faith,

confession, repentance, and baptism. Many more verses than those cited in this article can be found to further support each topic discussed. Any personal questions you may still have can be answered by continuing to study God's Word. After a thorough search of the scriptures, I believe most people will reach the same conclusion as Simon Peter: there is no where else to go but to the Lord. "Why shouldn't I become a disciple of Jesus?" There is no logical reason why you should not. Truly, God loves all of us and wants us to be with Him for eternity—even you and me.

4

The Upward Call
The Role of a Woman of God

by Patricia Gempel

For years there has been confusion in the minds and hearts of men and women concerning the woman's role in Christianity. Misapplication of scripture coupled with the secular campaign for female equality has intensified the confusion, leading many women into fear, discontentment, or rebellion.

We need to know what God wants and doesn't want from us as women so that confusion can be replaced with a simple love for God (described in I John 5:3 as *"obedience to God's commands"*). Matthew 11:28–30 tells us that these commands are not burdens but a flight of freedom for our souls. It is difficult to know, trust and implement God's word without discussion with others.

A look at Biblical examples of women helps clarify God's plan for all women, whether single or married, mothers or great grandmothers. Understanding some basic Christian concepts has also helped me personally to understand the specific direction God has given to me, a woman.

First, let's review several general principles for all God's

people: obedience to God; making disciples; the equality of believers; submitting to the authority of the leadership; and submitting to the needs of others. Then we will consider some specific directions given to women. As we study together, let us remember that all scripture is inspired by God (2 Peter 1:20) and written for all people. A few verses are challenges to men: others, to women. Our task is to understand and apply the scripture, not stand in judgment of it.

CHALLENGES FOR EVERYONE

Obedience to God

An understanding of our relationship to God is fundamental to an understanding of our role as women. Consider these verses: *"Therefore, I urge you, brothers, in view of God's mercy, to offer your bodies as living sacrifices, holy and pleasing to God-which is your spiritual worship. Do not conform any longer to the pattern of this world but be transformed by the renewing of your mind. Then you will be able to test and approve what God's will is – his good, pleasing and perfect will"* (Romans 12:1-2).

Our response to God's mercy should be a changed life, one that imitates Christ (1 John 2:3-6) Note that the transformation comes because of *"renewing your mind."* Our concept of women must never be molded by the pattern of this world. We are to have *"the mind of Christ"* (1 Corinthians 2:16), his viewpoint of life (2 Corinthians 5:16), his love for others (John 13:34) and his humble submission to God (Matthew 26:39, Philippians 2:5-8). Only then will we be able to discern God's *"good, pleasing and perfect will"* for our lives as women.

Mary, the mother of Jesus, understood obedience to God's commands. Initially, she was very frightened by the angel Gabriel's announcement that she, a virgin, would give birth to a son by the Holy Spirit (Luke 1:26–38). Her response, however, was *"I am the Lord's servant. May it be to me as you have said"* (Luke

1:38). Her obedience enabled her to become the most blessed of all women, the mother of our savior.

Can you say, *"I am the Lord's servant,"* as Mary did? In her song of praise to God (Luke 1:46–55), she rejoiced that God is "mindful of the humble state of his servant" and warned that he scatters *"those who are proud in their inmost thoughts."* An unbroken, prideful spirit will keep us from fulfilling our potential as godly women and destroy our contentment with God's plan for our lives. We must not only recognize God's authority but joyfully obey him, truly believing that as our Creator, he knows best what will make us happy.

Making Disciples

> *"Then Jesus came to them and said, 'All authority in heaven and on earth has been given to me. Therefore, go and make disciples of all nations, baptizing them in the name of the Father and of the Son and of the Holy spirit, and teaching them to obey everything I have commanded you. And surely, I will be with you always to the very end of the age.'"* (Matthew 28:18–20)

How many people have you taught or tried to teach to follow the Lord in the last couple of years? How many of them have since taught someone else to follow God? Jesus has entrusted the responsibility of making *"disciples of all nations"* to both men and women. We are ministers of reconciliation (2 Corinthian 5:18) and sharing His gospel to those will be lost for eternity unless we share what we know about God, Christ's sacrifice for us and the power of His Spirit.

The gospels record that after Christ was resurrected, he appeared first to a woman, Mary Magdalene, commissioning her to go report that he had risen (Mark 16:9, 10, John 20:10–18). Scripture abounds with evangelistic women who answered that

upward call. One of the most notable was Priscilla, wife of Aquila. She is mentioned with honor four times in the New Testament and twice commended for her fruitful labor in the kingdom of God (Acts 18:26, Romans 16:3). Paul acknowledged the source of Timothy's faith to be the faith of his mother Eunice which had been inspired by the faith of her mother Lois. Are you involved in discipling your children to Christ?

Things are wasted when they are used for the wrong purpose. We will not be satisfied as women until we are fulfilling our right purpose of seeking and saving the lost. Many of the qualities we are striving to develop as women—a calm and gentile spirit, hospitality, teaching the younger women what is good—are powerful characteristics of an effective soul winner. Let us use our femininity for the way God designed us. We are designed by Him to reach out to a lost and lonely world.

Equality of Believers

No one has done more to liberate women than Jesus Christ. In an age when females were ranked equal to slaves, Jesus acknowledged their worth and elevated their status to equality with males before God. The gospels record numerous accounts of Christ interacting with women on the same level as he did with men. He healed women (Luke 8:42–48)., shared his faith with them (John 4:4–26), allowed them to travel with his band of disciples (Matthew 27:55) and supported women when other men downgraded them (Luke 7:36–50, Mark 14:3–9). Women were also included in his discipleship groups (Luke 10:39). Most importantly, he promises both men and women that repent and have faith in God and his son, forgiveness of sin, the gift of the Holy Spirit and eternal life in the presence of perfect love, joy and peace if we remain faithful until the end of our life on earth.

The equality of believers is a scriptural principle from the Old Testament to the New. In Joel 2:29, God states that *"even on my servants, both men and women, I will pour out my Spirit in*

those days." Galatians 3:26–29 we read, *"You are sons of God through faith in Christ Jesus, for all of you who were baptized into Christ have clothed yourselves with Christ. There is neither Jew or Greek, slave nor free, male nor female, for you are all one in Christ Jesus. If you belong to Christ then you are Abraham's seed, and heirs according to the promise."*

Having equality before God means men and women are called to serve God as diligently as men. Our femininity gives us a different role than men. The lives of Esther, Sarah, the Proverbs 31 wife, Mary, and Priscilla show us the kind of service we should be rendering in God's kingdom. We strive for excellence from Acts to until today. Romans 16:1–16 records praise for the accomplishments of women in the early church.

Can you honestly say that you regard all Christians as equal in God's kingdom and that you strive to help all people follow Christ's example? Do you invite men as well as women to church? Do you allow your responsibilities as a wife and mother keep you from sharing your faith? If Paul had listed your name in Romans 16, would he have written that you had *"risked your life for him,"* been a *"great help to many people,"* loved others *"like a mother"* and *"worked very hard in the Lord"*?

Submission to Authority

The world teaches us to be prideful, independent and our own boss. When we become Christians, we must learn humility and submission. The command is very clear in Romans 13:1 *"Everyone must submit himself to the governing authorities."* That may seem unfair if you think your supervisor at work, or a politician is incompetent. However, Romans 13 continues to explain why we should submit *".... there is no authority except that which God has established."*

The authorities that exist have been established by God Romans 13:1–2 reads: *"He who rebels against the authority is re-*

belling against what God has instituted and those who do so will bring judgment on themselves."

Submission to authority within the church can be even more difficult, especially for those who have not yet given God complete control of their lives. We are instructed to "obey your leaders and submit to their authority. They keep watch over you as men and women who must give an account to God. Obey them so that their work will be a joy, not a burden, for that would be of no advantage to you" (Hebrews 13:7).

I frequently ask myself if I am respecting and obeying my leaders in the Lord. I try not to grumble, gossip, or complain to others about decisions that are made by them. Submission to authority makes sense to me when I consider what it does. It strengthens the leadership and strengthens the church (Romans 13:17). It strengthens me as I become more Christlike (Hebrews 13:7, Phil: 2:14–15), and it promotes unity (1 Thessalonians 5:12–13). If a leader is sinning however, I put Matthew 18 into practice.

Ruth was a woman who understood authority and received the blessing of submitting to it. She was known as *"a woman of noble character"* (Ruth 3:11). She showed reverence for God by accepting the authority of her employer Boaz. The book of Ruth records her diligent, wholehearted labor in Boaz's fields (2:7) as well as her humility, purity and honesty. The beauty of her submissive life won the heart of Boaz and he married her (4:9-11). Ruth, who had arrived in Bethlehem as a destitute widow, ended up with a home, a husband and a baby who became the grandfather of King David.

We need to view submitting to authority as part of God's plan for unity and growth, accepting and supporting those God has placed in leadership over us. *"Hold them in the highest regard in love because of their work"* (1 Thessalonians 5:13).

Submission to the Needs of Others
Philippians 2:3-7 teaches that:

Do nothing out of selfish ambition or vain conceit. Rather, in humility value others above yourselves, not looking to your own interests but each of you to the interests of the others.

In your relationships with one another, have the same mindset as Christ Jesus:

Who, being in very nature God,
> *did not consider equality with God*
> *something to be used to his own advantage;*

rather, he made himself nothing
> *by taking the very nature of a servant,*
> *being made in human likeness.*

God has never said it will be easy to give up our rights and put the needs of others ahead of our own, but He commands us to do that because he knows that it is only through self-denial and self-forgetting that we will find self-fulfillment. He created us *"to do good works"* (Ephesians 2:10), and to function on the fuel of sacrificial love—just as Jesus did. Selfish ambition is on the Galatians 5 list of sins because it destroys love and relationships.

Tabitha was a disciple who served others like Jesus did. Acts 9:36 records that she *"was always doing good and helping the poor."* Phoebe, *"a servant of the church in Cenchrea"* was a *"great help to many people"* (Romans 16:1–2), and Priscilla served so well that *"all the churches of the Gentiles"* were grateful for her (Romans 16:3).

In what ways do you *"submit to one another out of reverence for Christ"* (Ephesians 5:21)? When both you and your roommate want to take a shower at the same time, who steps into the shower? When you've had a long, hard day, do you still reach out to the person sitting next to you on bus or in the shop? Jesus washed the apostle's feet when he knew he would go to the cross in hours. He called us to follow his example, saying *"once you know these things, you will be blessed if you do them."*

All Christians are commanded to live obedient lives reflecting Christ (1 John 2:3–6). Each of us has been given the responsibility of making disciples (Matthew 28:18–20. All are equal before God with the same salvation and responsibility for others.

Yet men and women are obviously different, and the Bible points out that sometime the male and female have different roles. Two examples are in marriage and in the public worship. Also, older and younger women have different roles. As we continue to read God's word, please pray that we seek God's will as we examine the scripture together.

DIRECTIONS TO WOMEN

In the Public Worship

For many women considering Christianity, the female role in public worship services is a stumbling block. The scripture concerning that issue are nevertheless part of God's word.

> *"A woman should learn in quietness and full submission. I do not permit a woman to teach or to assume authority over a man; she must be quiet."* (1 Timothy 2:11–12)

> *"For God is not a God of disorder but of peace—as in all the congregations of the Lord's people.*
> *Women should remain silent in the churches. They are not allowed to speak, but must be in submission, as the law says. If they want to inquire about something, they should ask their own husbands at home; for it is disgraceful for a woman to speak in the church."* (1 Corinthians 14:33–35)

Obviously, God is not forbidding women to ever open their mouths within the church. We must consider these scriptures carefully and read them in the context of others. Women as well as men are commanded to encourage their brother and sister in

Christ (Hebrews 10:25), *"to teach and counsel one another with all wisdom"* (Colossians 3:16) and *"to sing psalms, hymns and spiritual songs with gratitude in our hearts to God"* (Colossians 3:16). The scriptures also make it clear that women in the early church actively used their voices to preach the gospel. Priscilla helps her husband teach Apollos (Acts 18:26). The four daughters of Philip the evangelist were blessed with *"the gift of prophecy"* (Act21:8,9). Even Jesus, our perfect example, entrusted women to go and talk about him to others (John 4:27-30, John 20:17–18, Luke 2:36–38). Women are to teach other women (Titus 2).

However, 1 Timothy 2 and 1 Corinthians 14 support the doctrine of male leadership and authority within the church. Women are not to usurp the authority God has given to men. The elders of the church (those with the greatest scriptural authority) are men (Titus 1 and 1Timothy 3). Also, Jesus chose 12 apostles. They were all men. Deacons are men.

Females have much to do. A different role is not a statement of female inferiority or inability. Rather it reflects God's desire for harmony. The same is true in a marriage. The man is the leader- has authority in the family. The woman has the role of being the mother (if God blesses the couple with children). The qualifications for eldership include having a godly marriage with a godly leader of women. The instructions in 1 Corinthians 14:34, 35 are prefaced with the explanation that *"God is not a God of disorder but of peace"*1 Corinthians 14:33. His design is that everything be done in a fitting and orderly way (14:40). When men and women function in their God given roles, they present a powerful model of family unity to a world in chaos.

There are many avenues of service in the church open to women. The contributions of women were vital to the success of the early church (Romans 16). In my lifetime I have seen submission used as a synonym for laziness and a license to hide one's talents and an excuse to fail to take initiative. About half of the world's population are women. I try my best to reach as many of

them as possible.

I personally had the greatest difficulty with these Scriptures when I had the least knowledge of God and His word. I am increasingly trying to submit to his wisdom.

In Marriage

One of the most complete texts describing the lifestyle of a married woman is found in the book of Proverbs. She is a wife of noble character, ambitious and hard working.

- She fears God and teaches others (Proverbs 31:27–30)

- She is the wife of a godly leader (verse 23)

- She respects and supports her husband (verse 12)

- She is respected for her accomplishments (verses 11, 25, 28, 29, 31)

- She is responsible for her household and children (verses 15, 21, 22, 27–28)

- She is a merchant and real estate broker (verses 13, 14, 16–19, 24)

- She is a hard worker (verse 17)

- She shares with others in need. (verse 20)

The Proverbs 31 woman builds up and supports her husband. Her life is an upward call for all married women striving to follow God's commands.

Once I read those verses during a Women's Bible discussion with a group of women who were unfamiliar with the Bible. Their responses ranged from "You must be kidding" to absolute silence. Can you guess why?

A more controversial scripture about a woman's role in marriage is Ephesians 5:22-24: *"Wives, submit to your husbands as to the Lord. For the husband is the head of the wife as Christ is the head of the church, his body, of which he is the Savior. Now*

as the church submits to Christ, so also wives should submit to their husband in everything."

There are two meanings of submission. The first definition is to willingly put the needs of another ahead of your own, as in Ephesians 5:21—*"Submit to one another out of reverence for Christ."* The second meaning, in Ephesians 5:22 (and Hebrews 13:17), referring to the marriage relationship and church leadership. Means to willingly submit to another's authority. The key word is willing. It is your responsibility to obey God in this. This is important and relates to the male/female roles established by God. God is giving instruction for His family and our family.

Today's society equates submission to as an admission of inferiority. Some men have abused their position of leadership and become tyrants. That complicates our understanding. Others lack confidence in gaining female respect. The result can be rebellion at the seeming injustice of a woman's role. Mankind's failure doesn't change God's teaching about marriage. His word tells us what will bring peace in our biological family and in His family—the church and His kingdom.

Viewing God's perspective, puts submission in a positive light. The Lord, not man, designed marriage, knowing what will make it work best. He put submission into the relationship to create order, not inferiority. Someone must be the leader, and God gave that responsibility to the husband. A man's authority over his wife is not earned; it is assigned by God. Submitting to that authority does not say he is superior, or you are inferior. It simply fulfills our God given responsibility.

God will hold accountable men whose leadership does not reflect God's own character. A husband has no right to look down on his wife. 1Corinthians 11:11–12 teaches that men and women are dependent on each other, and both are dependent on God. Genesis 2:18–24 explains that man needs woman and is incomplete without her. Only together do they represent the image of God (Genesis 1:27). Ephesians 5:25–33 commands husbands to

love their wives *"just as Christ loved the church and gave himself up for her."*

However, the scripture does not say to be submissive to your husband if he loves you as Christ loved the church but to be submissive *"in everything."* Wives often hinder the development of their husband's leadership by nagging or complaining, verbal abuse, disrespect, and distrust. Once a woman told me, "I respect my husband. The only problem is I respect myself more." It is difficult to live with someone, to know their strengths and weaknesses and still respect them and their authority. That is why, I think, God included Ephesians 5:33 in his command to wives.

We must learn to concentrate on the 95 percent right that our husbands do and help them overcome the 5 percent wrong they need to change, or remember the Lord's words *"Father forgive him, he doesn't know what he is doing."* We must fight the feeling that my husband isn't looking out for our good and trust God who has given them the authority to make decisions, believing God can turn even a bad decision into a blessing. We can discuss our feeling and express our opinions-respectfully and in love—but if there remains a disagreement, our direction is to be chosen by our husband. Hard for me to do!

What if your husband tries to direct you into doing something ungodly? Acts 4:19 and Acts 5:29 give the answer: we must obey God rather than man when directions are incompatible. The book of Esther also addresses this issue. When Esther learned that her husband, the king, and an unbeliever, had approved a request to kill all the Jews, she respectfully worked to change her husband's decision She was willing to die, if necessary, to save her people. Esther showed us how to be respectfully submissive and still put God first.

Some women say, "My husband is not a Christian. How can I respect him?" 1 Peter 3:1–6 tells us to win him over with actions not words and to do what is right regardless of what he does. Rationalizations are not accepted by God. 1 Corinthian 7

teaches that a Christian is bound to a non-Christian spouse if he is willing to live with her. Only adultery (Matthew 19) or the non-Christian mate leaving can sever the marriage. If you continue to be submissive to the authority God has given even your unbelieving husband, the resulting "purity and reverence of your life" is your only hope of winning your unbelieving husband to be a believer in God. (1 Peter 3:1–2)

2022 addendum.

God's word is true and unchanging from Genesis through Revelation. My opinion hasn't been changed since 1984 when this was written. Since my husband of almost 50 years went to be with God in 2019, I have tried to be closer to Him and worked harder to put Christ's example into practice in my life. My prayer is that you will also be closer to Him. May God bless you. Please pray for me as well. Life without my partner and leader is harder than I thought.

May God use me to help you. I love you and God loves you more.

—Patricia Gempel

SECTION TWO

Teaching Each Other

5

Discipling Relationships

by Elena McKean

There is confusion today about the woman's role in the church. This has led to a failure to develop strong female leadership, historically. Women are not to hold church offices, such as elders (though they are qualified by raising believing children and wives able to teach women), deacons or evangelists (2 Timothy, Titus). However, the church desperately needs women who are respectable and able to teach other women how to become Christians and mature in their faith. Female leadership is essential in winning the world to Christ. Hopefully this book will help us grow in our leadership of women.

The Bible does clearly teach that the older women in Christ are to train the younger women (Titus 2:3–5). We are to teach one another what is "good". The Bible is filled with an amplification of *"what is good."* Just as Jesus is our perfect example of the type of character we should develop, he is also the best model to follow in our discipling relationships. His training of the twelve apostles provides us with six steps towards maturing each other in Christ they are:

1. Communion with God.
2. Commitment to one another.
3. Concentration on a few.
4. Comforting and learning from one another.
5. Challenging one another to follow Christ example, with scripture and gentleness.
6. Camaraderie with each other.

1. Communion With God

At the center of all our relationships should be our desire to please God and teach His word. We have a personal relationship with Him (2 Corinthians 5:9) which we treasure. What pleases God is that all people come to Him (1 Timothy 2:3–4) and are saved. He loves us and wants us to be with Him for eternity. We take our responsibility to do His will, seriously (1 Timothy 4:7–8). Training in godliness, a training that dominates our life for as long as we live, requires Bible study, submission to the authority of the Word and prayer to learn. We can't teach what we don't know! How well do you know God's word?

Knowledge of the scripture is not sufficient. John 5:39–40 reads: *"You diligently study the scriptures because you think that by them you possess eternal life. These are the scripture that testify about me, yet you refuse to come to me to have life."* We must come to God honestly, and humbly submit to His will. As 1 Thessalonians 2:4–6 teaches:

> *On the contrary, we speak as those approved by God to be entrusted with the gospel. We are not trying to please people but God, who tests our hearts. You know we never used flattery, nor did we put on a mask to cover up greed—God is our witness. We were not looking for praise from people, not from you or anyone else, even though as apostles of Christ we could have asserted our authority.*

Our communion with God will enable us to genuinely care for one another without ulterior motives, flattery, or masks to cover up greed, or any other sin. I witnessed a very tragic example of someone knowing the scriptures well yet refusing to submit her life to the word. This highly talented woman could quote passages and discuss them in a meaningful way, but she put up a façade that was hard to see through initially. After several months of trying to get to know her, concerns arose about why her life wasn't changing to be more Christ-like and why her relationship were souring after supposedly building deep friendships. She even won some people to Christ, but they weren't maturing, and they were fearful of this woman. Many deliberate sins, especially sexual sins, and deceit (which often accompanies sin) were eventually uncovered. Several strong Christians tried to help her work through these struggles. However, she enjoyed her sin more than she wanted to please God. She left the Lord and His Church. She influenced others to sin by getting them involved in her sins.

Powerful lessons came from that discouraging situation. When we are not trying to abide and commune with God in an ever-growing manner, we are apt to fall under Satan's schemes. We can't be discipled by other or disciple others without God's help. He must lead us. We must be open with each other. John 15:1–10 teaches us:

> *"I am the true vine, and my Father is the gardener. He cuts off every branch in me that bears no fruit, while every branch that does bear fruit he prunes so that it will be even more fruitful. You are already clean because of the word I have spoken to you. Remain in me, as I also remain in you. No branch can bear fruit by itself; it must remain in the vine. Neither can you bear fruit unless you remain in me.*
>
> *"I am the vine; you are the branches. If you remain in me and I in you, you will bear much fruit; apart from me you*

*can do nothing. If you do not remain in me, you are like a
branch that is thrown away and withers; such branches are
picked up, thrown into the fire and burned. If you remain in
me and my words remain in you, ask whatever you wish, and
it will be done for you. This is to my Father's glory, that you
bear much fruit, showing yourselves to be my disciples.*

*"As the Father has loved me, so have I loved you. Now
remain in my love. If you keep my commands, you will re-
main in my love, just as I have kept my Father's commands
and remain in his love."*

Our discipling relationships should motivate us to draw
closer to God through prayer. This leads us to the next objective.

2. Commitment to One Another

Jesus was constantly giving of himself to others. He was
especially committed to the twelve apostles. He spent three years
devoted to these men, teaching them about God, how to be united
and committed to working together, and how to get the message
of the gospel to those who didn't know Christ (John 17:6–23). In
the gospels we can see how Jesus constantly served the twelve
with love and daily shared his life with them. Paul's example (1
Thessalonians 2:8) was one of loving people so much that he
was delighted to share not only the gospel with them but his life
as well.

Helping each other to mature in Christ takes sharing our
lives, which is not always convenient. But because we love God
and one another we'll make the extra effort to keep in touch,
to encourage one another and to serve one another. We need to
develop Christ's attitude in looking out for the interests of others
and considering others better than ourselves (Philippians 2:3–5)
to disciple one another. When we ask someone to have a disci-
pling relationship with us and then don't communicate consis-
tently, we won't see growth in the relationship.

I am committed to discipling relationship with four women. I've found that sharing our lives by phone daily, meeting once a week for a couple of hours to talk and pray, and seeing each other in church fellowship at least twice a week are barely adequate to help each other mature. Yes, these times help us to know one another, but we need to be committed to truly serving one another and sharing our lives. In addition, we've shared our families, we've shared our faith together with other people, we've gone on retreats, run errands, and enjoyed numerous fun activities together. It has taken discipline for me to devote myself to these women, especially of my "free-time" and even sometimes sleep-time. But I am devoted to them. We are both striving for spiritual maturity-to become more like our Lord. I want to feel responsible for the spiritual growth of others, as Jesus did.

3. Concentration on a Few

Concentrating on a few disciples is vital in developing life-changing relationships. A common mistake made in discipling is to try to affect too many people. We need to reach out to unbelievers and do what we can for other Christians. We are trying to help a few grow to feel like our family in God's church, the family of God. Jesus concentrated on the twelve apostles without neglecting the masses (Mark 3:13–19). He wasn't married and had the twelve as his close family. He lived with them for three years. They walked with Him and watched Him do miracles and He taught them to carry the message around the world.

Having the responsibilities of a wife and mother of two children, I've prayerfully selected four women to have discipling relationships with me. I am studying the Bible with three women on a weekly basis. I am building relationships with others that aren't yet believers. I am trying to follow the example of our Lord and taking advice and praying.

As an evangelist's wife I feel a special need to build strength and unity in the church, particularly among women. To help fill

this need, I meet with one elder's wife, one deacon's wife and one other evangelist's wife on an individual basis. We share our lives and pray together. Those three women have been a great source of wisdom in training me to be more like Christ. As a result of our discipling efforts, these three women are now my closest friends, next to my husband and the Lord who is my best friend.

As Titus 2:3–5 teaches, the older women have helped me to love my husband and discipline our children, to be more self-controlled in overcoming sinful emotions, such as anxiety and self-pity, to be busy at home, to entertain with more efficiency and joy and to be more kind. Some of God-given strengths have helped them to mature in winning souls to Christ. The woman who is now one of our evangelists" wives is younger than I am spiritually and physically. Four years ago, I helped convert her to Christ. We have grown in our discipling relationship since then, and she has won several other women to Christ who have in turn been fruitful.

In addition to individual time with each other, the wives of our elders, deacons and evangelists meet as a group once a week for two hours. We pray, share our ministries and personal struggles, and discuss needs in the church with the women and children. We've reaped much strength and spiritual growth from these times. The ideas generated in them have enable us to give our elders and evangelists effective suggestion for building up the church. Concentration on a few disciples can have a dynamic effect on maturing ourselves and those around us.

4. Comforting One Another

The Christian life has its share of difficulties and painful trials. Such times can be burdensome and spiritually distracting. We need to learn how to comfort one another, to impart strength and hope. Paul wrote about the need for comforting in 1 Thessalonians 2:12. Can you remember a time when you were hurting? Did you receive comfort from anyone? We need to be sensitive to

the needs of others, trying to be empathetic and not necessarily sympathetic.

Some of the disappointments we encounter are a hard day with sick children, someone not wanting to study the Bible anymore, dating or marriage problems and Christians who aren't doing well spiritually. The person who is trying to disciple others must be aware that hard times can create spiritual valleys. At those time, all need to pray together and search God's word to be comforted. Friends are a part of that equation. Our daily walk with disciples helps us to know when they need prayer, comfort and counsel.

I'll never forget an experience I had one summer. I arrived at a sister's wedding and received the tragic news that her father had passed away. She needed the comfort that only a close Christian friendship can provide. We cried together (1 Corinthians 12:26), held on to one another, and immediately went to my home and prayed together. In the days that followed I tried to be a source of encouragement and challenge to her in order to keep her faith strong.

Comforting one another is an important objective in discipling friendships. We do have a *God of all comfort, who comforts us in all our troubles with the comfort we ourselves have received from God"* (2 Corinthians 1:4).

5. Challenging One Another

For most of us, challenging one another is not something that comes easily or naturally. One of my greatest problems in discipling other women has been a worldly desire to avoid conflict. Part of this problem involves not wanting to hurt the feelings of these women or endanger our friendship. I have realized that I fear the person I am challenging will be comfortable challenging me.

Jesus directly challenged the twelve apostles on many occasions on such issues as their weak faith (Matthew 8:23–

27, Matthew 14:31, Matthew 17:20), their lack of hospitality (Matthew 14:16), Their pride (Matthew 18:15, Matthew 19:13–14), their lack of sensitivity (Matthew 26:40–41), and their worldly thinking (Matthew 16:23) If we are to stay true to Christ's example, then we also must be challenging in our discipling relationships.

There are two ways we can challenge other disciples: by our lives or example and by God's word which we share. Both are important (1 Timothy 4:16). We need to make our challenges clear basing them on the goal of helping each other mature in Christ. *"We proclaim him, admonishing and teaching everyone with all wisdom, so that we may present everyone perfect in Christ. To this end I labor, struggling with all his energy, which so powerfully works in me."* (Colossians 1:28–29)

The people who have had the greatest impact on my life are those who have challenged me. I'll never forget one of my husband's challenges a few years ago. He confronted me on my desire and efforts to help build a great church and not just a "good little church." I cried, but realized he loved me and wanted me to give my best to the Lord. We discussed some practical ways I could change my attitude and efforts. Making the sacrifices necessary to build a great church has been difficult for me. I pray daily for strength, greater faith, and a spirit willing to deny self. It has been exciting to see how God has since helped me to be more faithful than I ever imagined.

One of my closest friends in the Boston Church of Christ is an elder's wife who has been willing to challenge me on several occasions. One of these challenges involved my need to become more confident in the Lord, rather than giving in to self-pity during a period of poor physical health. In fact, I felt stronger by the next day because of taking that challenge. On another occasion a younger sister challenged me to be more open with my life. She was right, and our relationship grew stronger as I learned to share my struggles with her and others.

6. Camaraderie With One Another

Of all the objectives of Christ's ministry with the apostles, the most obvious and yet most overlooked is camaraderie, Mark 3:14 states: *"He appointed the twelve-designating them apostles-that they might be with him and that he might send them out to preach."* Jesus' friendships weren't an end in themselves. They were for the ultimate purpose of training those men to spread the gospel.

Key aspects of camaraderie are working together to win people to Christ and making other Christians aware of ways they need to change to be more effective. We need to be partners in the gospel (Philippians 1:5) and to love one another as Jesus loved us (John 13:34–35) so that the world will know we are truly Christ's disciples. Just as Jesus shared fun-times (wedding and dinner parties) and serious times (discussing his death) with his apostles, we too should be sharing our experiences with those we want to train and be trained by. Such sharing develops a bond between two people, a bond through which we can teach profoundly, not only by our words but by our lives (Luke 6:39, 40).

Now ask yourself honestly: Are my closest friends' Christian women who I trust and who are discipling me to Christ? Have I studied the Bible with someone who is now a Christian and helping others to become Christians? If so, you are probably fulfilling God's objectives for your relationships: to commune with the Lord; to be committed to one another; to concentrate on a few disciples; to comfort and challenge each other to be friends and followers of Christ. If not, please remember God's commands are not options for disciples of Christ. Let us pray to follow the example of our Lord.

6

Motivating Others

by Patricia Gempel

Men and women have always been motivated to follow confident leaders. Kings have led us into battle, politicians into corruption and humanitarians into benevolence. Jesus Christ leads us to follow God (John 14:3). The greatest leader of all time, he was able to influence the entire world by motivating twelve men to follow him. Two thousand years later, his life continues to affect, change, and motivate others.

Just before Christ ascended, he transferred the responsibility of motivating others to follow him to you and to me (Matthew 28:18–20). This lesson will explore how standing for the right, having vision for another, and holding others accountable will enable us to fulfill that mission.

Standing For the Right—to the point of sacrifice

Jesus Christ distinguished himself as the only human being to ever live a life completely obedient to God. Christ's obedience or standing for the right is what allows us to know God and help others know him.

Jesus faced every temptation we face yet never sinned (Hebrews 4:15). He was tempted to be prideful, to seek power, and to give up when things were hard, but he continued to be obedient to God, demonstrating true courage and strength. He is our perfect example of self-control. He did not let his fears undo him as he faced the most challenging time of his life, the cross. He prayed for God's power to follow through with their plan. In Mark 14:33–36 we read:

> *He took Peter, James and John along with him, and he began to be deeply distressed and troubled. "My soul is overwhelmed with sorrow to the point of death," he said to them. "Stay here and keep watch."*
>
> *Going a little farther, he fell to the ground and prayed that if possible the hour might pass from him. "Abba, Father," he said, "everything is possible for you. Take this cup from me. Yet not what I will, but what you will."*

Three times Jesus prayed and then began his walk to the cross. Rejected and denied by his apostles, beaten, ridiculed and finally crucified, he gave us a perfect example of sacrificial obedience to God's will, no matter what the cost, His plea is for us today to help each other do the same.

How Do I Begin Sacrificing?

Our task is to motivate ourselves and others to want to be like Christ. We must see the need to change, understand how to change, and generate the desire to change in ourselves and others. That requires action to the point of sacrifice.

That is why me must desire to be like Christ. That is what it means to repent. Few of us have ever shed blood for the sake of doing right. Some of us may have been ridiculed and a few completely rejected. It shouldn't surprise us, therefore, that we have difficulty relating to Christ's perfection and the extent of his

sacrifice. Yet we are called to follow his example (Luke 14:27) and to sacrifice whatever is necessary. (Mark 8:34–37).

My experiences have shown me that learning to sacrifice begins with doing things I know are right but aren't convenient. Decide to use the opportunities given you each day to do what is right, that is, to love and obey God (1 John 5:4). To motivate others, we ourselves must obey God (1 John 5:4). To motivate others, we must be doing what we know is right and encouraging others to do likewise. Ask yourself: am I making the most of my opportunities? Consider these:

- Am I praying that God will draw me closer to him? (Psalm 51:10) and that He will lead me today to do whatever He sees I can do?

- Am I hungering and thirsting for righteousness? (Matthew 5:6)

- Do I study God's word each day? (Colossians 3:16)

- Do I pray on all occasions? (Ephesians 6:18)

- Do I share my faith every day? (Luke 19:10)

- Do I help others mature in their faith? (Ephesians 4:14–15)

When we start trying to follow Jesus, it is a sacrifice to do those things at all. Our priorities must constantly be rearranged (Matthew 6:33). As we grow in putting our faith into action, our motivation to sacrifice increases, and we do those same things more willingly. The union of faith and action is what makes us complete (James 2:22). Jesus' sacrifice encourages me to sacrifice which in turn encourages someone else to sacrifice- and the discipling, motivational principle is repeated.

How Do I Know I'm Sacrificing?

Sacrifice is a personal thing. What is a sacrifice to me may

not be a sacrifice to you and visa-versa? What is **right** or scripturally correct is absolute. For example, Jesus told us in John 15:16–17: *"You did not choose me, but I chose you and appointed you so that you might go and bear fruit—fruit that will last—and so whatever you ask in my name the Father will give you."* So, he promised us that God will give us whatever we ask in his name. The teaching to bear fruit and to pray for what we need is clear. Many times, I have been obedient to this teaching—without sacrifice. But when I give something up to do right, it always means more to me and others.

Recently I was called to sacrifice to obey. A few days before Christmas, a situation developed when our two children and their mates arrived home for the first time in many months. My parents had also just arrived. We were excited as we anticipated a family dinner and a long evening together. Then, we received a call from a new brother who wanted my husband and I to study the Bible with a friend of his from college who would only be in town a few days.

Because of other commitments, this was the only time they had available. What should we do? Where should we place our priorities? After talking and praying about the situation, we decided to do the Bible study that night. It meant sacrificing precious time with our family and praying to have the right attitude. God answered that prayer as well as our desire that the study would make a difference in the life of each person. The young Christian is much stronger today because he has been successfully sharing his faith. His friend has begun learning how to follow God. And our family's visit was great even without those hours.

Christ's sacrifices were necessary to motivate us to do right. We must be willing to sacrifice also to encourage and motivate others to follow Christ's example. Sacrifice allows us to grow in our ability to do what is right and is prompted by a spirit willing to obey. Remember: you are sacrificing when you are **doing right regardless of convenience.**

Vision For Another—Growth through the counsel of disciples

Having clearly and lovingly defined responsibilities and goals for growth, is another key to motivating others. Discipling relationships must include giving one another concrete ways of meeting goals and fulfilling responsibilities. What do you want to be doing in three years? What do you expect those around you who are striving to be like Christ to be doing in three years? Based on the teaching of Christ in John 5, what vision and goals does he have for you and me in the next three years? My deep desire to please God coupled with His vision for me motivates me to submit to His authority in my life. My concern for others growth causes me to have vision for them.

Have God's Vision For Yourself

If we are going to motivate others to grow, we need to be enthusiastic, God-seeking perpetual students of his word. We can't teach what we haven't learned. This is easy to understand in the secular world. We learn how to drive from a driving teacher. We study chemistry with the most experienced and knowledgeable chemistry teacher. Everything we know, we learned from someone else.

Learning from God, our creator, the one that can give us peace and teach us to love and sent His son to be a sacrifice for us, is different. We should approach God humbly not telling us what we want but asking Him what we should do. He knows what we are struggling to attain. We should ask for His wisdom and His direction and ask Him to put His will into our minds and hearts and the minds and hearts of other disciples that we trust.

What kind of teacher are you? Jesus commands us to be people filled with love, joy, peace, patience, kindness, and self-control (Galatians 5:22–23). He wants us to be respectable (Titus 2), good listeners (James 1:19) and fruitful (John 15:1–8).

We must:

1. Obey God's commands.

2. Remain in Christ's love (John 15:9, 10).

3. Love others as Jesus loves us.

4. Lay down our lives for others (1 John 3:16).

5. Teach others (1 John 3:16) and teach them to obey what He commands (Matthew 18:18–20).

I am challenged by these thoughts. We want to motivate ourselves and others to change-but how? Enthusiastically teach God's word. Share your knowledge in a very specific, positive and loving way. Commit yourself to individuals and believe in their ability to change. Understand that all things are possible with God (Mark 10:27) and that no one has every been overcome who wanted to stand firm (1Corinthians 10:12–13). Learn from and teach each other with the depth of commitment that David and Jonathan had for each other and with the sincere love of Christ. **Pray always for God to show you how.**

Have Vision For Your Friends

In John 15, Jesus called himself our friend because he taught us everything God taught him. As we try to motivate others to change, deep friendships should develop. Consider my relationship with Donna who is my sister, twice, spiritually, and physically. Donna is thirteen years younger than I am and single. She has, by nature, humor, compassion, and a love for God. Four years ago, she moved to Boston and became a Christian. My vision for her was that she become a Bible discussion group leader who could successfully lead others to the Lord and mature them in their faith.

My vision was followed by specific instruction. I believed that if she would just keep learning, keep praying and keep

trying, she would succeed. I praised her successes and critiqued her failures. We have had some talks that challenged both of us. Donna says sometimes I have been "obnoxious." With time we both changed. My vision is being fulfilled and Donna is bearing lasting fruit. Those she is influencing are influencing others. As we continue to teach one another what we have learned from Christ, our friendship has deepened and drawn us closer to one another and to the Lord.

There are many others I work with closely. I dream of what they will be someday. In each case, I see their unique talents and believe they can add to those talents through specific instruction and practice. I think of Jennifer who works with me and is teaching me patience as I teach her completeness and timeliness. Syntcha is developing confidence to add to her brilliance. Kim Ann is learning to share her faith. Elena, the one who has taught me most about Christ's gentleness, has been learning to be a stronger and more confident minister's wife. Betty is learning to express her love and compassion. Muriel, one of the boldest soldiers of Christ I know, is learning to communicate effectively. Those relationships require commitment **to the Lord and to teach each other.** They are dynamic, challenging at times and always encouraging. Specific teaching in real-life situations has changed those willing disciples of Christ to be more like him.

Think about God's vision for you. Dream about what God can accomplish through you and those around you. Become friends with each other as Jesus is our friend. The specifically communicated vision of a friend enable a person to grow more quickly. Don't expect absolute perfection but be encouraged by constant.

Accountability—a motivation to achieve

A third essential element in motivating others is being willing to hold another person accountable to Christ's example. On judgment day, we will be held accountable by God for the impact

of our lives. He will judge us by the words of Christ (John 12:48) and reward us according to our individual labor (1 Corinthians 3:8). We have been warned to work and build carefully (1 Corinthians 3:10) so that God can make our efforts grow (1 Corinthians 3:7). When we keep those scriptural concepts in mind, we are grateful for brothers and sisters who love us enough to hold us accountable for our productiveness in God's Kingdom, his church.

Each person needs to accept responsibility for the outcome of his efforts and be willing to be held accountable. Again, we understand this concept in the secular areas of our lives. We have all been held accountable for learning in school through exams and grades. How many tests have you taken in school? How many exams have you taken to test your knowledge of God's word? What was your attitude toward such an exam? Were you eager to be held accountable? At work, we are held accountable by deadlines. When we miss our deadlines, our supervisors are upset, and we may not get a raise or promotion. When my secretary doesn't come to work on time or doesn't accomplish an assigned task appropriately, she is held accountable.

Hebrews 3:12–13 commands us to hold each other accountable for our spiritual growth and performance. Our growth is an eternal issue. We can do that in the following ways:

1. Express your desire and willingness to learn from and teach one another to be Christ-like. Each individual needs to have specific goals. Successful growth should be rewarded with sincere positive encouragement. Lack of success should be acknowledged as we try to succeed (Ephesians 4:16). Without this kind of communication spiritual growth at best will be slowed. If discussions don't go well, it can steal the joy of our friendships and our desire to grow. Pray for God to lead you.

Sell your books at sellbackyourBook.com! Go to sellbackyourBook.com and get an instant price quote. We even pay the shipping - see what your old books are worth today!

00067512365

Common responses to being held accountable are defensiveness, resentment, bitterness, hurt feelings and giving up. If these are feelings you have had, examine yourself and pray. Ask yourself whether there is pride, a misunderstanding of the purpose of Christ-like relationships? Is it a lack of Biblical knowledge? Whatever the reason, overcome and strive to be open, with self-control say what you are thinking to someone that can help you read the scripture and persevere. God is with you.

2. Work through every problem that arises. Christians are challenged to be united (John 17). Many times, though, we mistake glossing over problems for unity. In our hearts we know the difference, but our actions are inconsistent.

 Few people I know enjoy working through sticky situations with a brother or sister. Matthew 18:15 tells us how to do that in a Christ-like way. Nevertheless, we want the conflict to disappear without any real effort. We become **lazy** and superficial in our analysis. If you are going to be effective for the Lord, however, you must respond to his prayer in John 17 and be as united with your brothers and sisters as Jesus is with God. There must be no divisions between us. This does not mean that we won't ever get angry or that we won't need to work through differences. It means what it says: there should be no differences remaining between us.

How An Evangelistic Team Holds One Another Accountable

We must motivate one another to work as partner in the gospel, coaching individuals on how to be part of a team effort. In

1 Corinthians 12 and Ephesians 4 we are taught that working together as one body pleases God and is essential for our growth. John 15:17 describes the way to achieve unity: *"This is my command: Love each other."* This is difficult for men to do. In my opinion is more difficult for us girls to do. Let me share what that means to the Bible Discussion Group (the small evangelistic team) that meets in our home. Our goal is to help others find God and for each of us to continue to be increasingly effective. Our motivations are to please God and help each other. This group works together to learn about leadership, discipleship, and evangelistic effectiveness. We are held accountable by the leader of the group and one another.

We have a group of ten multi-talented Christians that meet in our home once a week for a one-hour Bible discussion. The one-hour meeting is a small part of our relationship with each other. During the week, we each see other members of that group several times. We have fun together, helping each other to get acquainted with others who visit the discussion group. Every other week we have dinner together. We study the Bible with each other and with friends who aren't yet Christians. We meet as friends to discuss ways to change to be more like Christ (Hebrews 10:23–25). We bear one another's burdens: physically, emotionally and spiritually. When misunderstandings and bad feelings arise, we work together to settle our differences (Matthew 18:15). When one struggles, all come to their aid. For the past two years, this team has doubled itself each year. The people that have become Christians are men and women from 15 to 82. Some are married, some single. Almost all are still faithful Christians. Several new discussion groups have been started and new leaders have developed. We work as a team to help others find God and to help each other grow strong. Each person is growing in their sense of responsibility to the others in the group.

We learn about leadership from the team leader, my husband. My role in this group is to support his leadership and to be

personally fruitful myself. He sets goals for our group, and each member responds. He sets the pace for all of us with love and loyalty to each Christian team member. He is the most effective teacher, soul-winner and soul-maturer on the team. He teaches us what he knows. Others grow because of their relationship with this enthusiastic, positive leader.

Another important key to the continued growth of our team-truthful teamwork. It is written in Ephesians 4:15—each member strives to speak the truth in love....as each part does its work. We work together to keep each other strong and share our beliefs with others. We have observed that this love, loyalty, sacrifice, and specific teaching draws others to God.

Summary: Motivating Others

1. **Standing for the Right—to the point of sacrifice.** We want to motivate others to desire to be Christ-like. The word of God tells us what to do. Our task is to live a life that shows we are following Christ and then to teach others to obey also. We must do and teach what is right with the intensity and goal orientation which meaningful personal sacrifice inspires.

2. **Vision for another—growth through the specific counsel of friends.** Our growth and the growth of others depends upon how clearly, we understand Christ's vision and call to grow. We need to help each other understand what we can do. Frequently, we can't see clearly what it is that we can accomplish. We need to help each other see Christ's vision and help each other realize the victory. To do this, we must be involved in each other's lives.

3. **Accountability—a motive to achieve.** Our goals, responsibilities, and vision are all measured by God by what we accomplish. We need to hold each other

accountable for our own growth and the growth of others. To God be the glory, great things HE can do through a willing, visionary person who isn't afraid to be help accountable. Jesus held the apostles accountable. Amen. I love you. I am praying for you.

SECTION THREE

Uncommon Unity

7

Learning to Love

by Joyce Arthur and Tanya Lloyd

The greatest commandment, as recorded in Matthew 22:37 is to *"Love the Lord your God with all your heart, with all your soul and with all your mind."* The second greatest commandment is to love your neighbor as yourself. Jesus clearly considered loving God and others as his most important message, emphasizing it as the root of every aspect of the Christian life. In Matthew 22:40 goes on to say that everything God has taught and recorded in his word "hangs" on the command to love. Without learning what love is and how to love, we cannot be obedient to God's greatest commandments.

What is love for God and how can we learn to love? 1 John 5:3 states that love for God is obedience to his commands. Today, love is thought of as a feeling or mood which is not how God defines "love." God makes love very tangible by telling us simply to obey him.

Obedience is a learning process. One sees what is right and puts it into practice as Jesus did in 1 John 3:16–18. Christ demonstrated his perfect love by laying down his life for us. We

are admonished to do likewise. That kind of obedience will develop our ability to love as Jesus did and will give us a foundation for learning how to love.

I Corinthians 13:4–7 contains God's explicit definition of love in practical terms:

> *Love is patient, love is kind. It does not envy, it does not boast, it is not proud. It does not dishonor others, it is not self-seeking, it is not easily angered, it keeps no record of wrongs. Love does not delight in evil but rejoices with the truth. It always protects, always trusts, always hopes, always perseveres.*

Love is Patient—it is not easily angered

Your interaction with others during the trials you experience with them reveals how much you really love them. A loving woman is not easily angered or irritated nor does she keep a record of wrongs. Instead, she responds with patience as in Proverbs 14:29: *"Whoever is patient has great understanding, but one who is quick-tempered displays folly."*

The Christian woman ought to bear calmly with others through difficulties, helping them to resolve conflicts rather than complaining or being intolerant of weakness. James 1:19–20 teaches that: *"Everyone should be quick to listen, slow to speak and slow to become angry, because human anger does not produce the righteousness that God desires."* In both our marriages, we have been blessed with husbands who have loved us in this way, especially during the early days of the ministry here in London. We know they love us because they are steadfast in their support, correcting and encouraging us with great patience. We also feel loved because they don't keep remembering our wrongs.

Proverbs 10:12 warns that *"hatred stirs up dissension, but love covers over all wrongs."* If we want to truly love others, we

must truly forgive and forget their mistakes, without storing up past wrongs for future ammunition. Correct others' errors and move on, bearing patiently with them through whatever happens next.

Love Is Kind—it is not rude

Kindness is a quality that causes a chain reaction. When someone does a kind deed for you, the natural response is to do something kind in return. We should have the same response toward God for the great kindness and mercy he has shown us as sinners. Ephesians 4:32-5:2 describes the loving kindness of God that we should imitate: *"Be kind and compassionate to one another, forgiving each other, just as in Christ God forgave you. Follow God's example, therefore, as dearly loved children and walk in the way of love, just as Christ loved us and gave himself up for us as a fragrant offering and sacrifice to God."*

Christ demonstrated his love by laying down his life for us, perfecting kindness by doing something he knew we didn't deserve. God shows us that same act of mercy by forgiving us while we are still in our sins. Ask yourself: how am I responding to his kindness?

One sister in our congregation shows her appreciation for God's kindness by being a true friend and neighbor. She is known and loved by virtually everyone in her residence hall because her door is always open to offer a cup of tea or a listening ear. The result of that lifestyle of love has been abundant fruit during her first six months as a Christian.

In contrast to kindness, rudeness is a great obstacle in our relationships. We can be rude in many ways, such as being abrupt, impatient, and insensitive or engaging in foolish talk, coarse joking, and bitterness. When love is lacking in our lives, we will act that way toward our families, friends, and acquaintances. Such damage can be avoided by continuing the chain reaction of God's kindness and acting out of His love.

Love Rejoices In The Truth—it does not delight in evil

In learning to love, one must determine a source from which to learn. As Christians, we logically turn to God's word, the Bible, as our standard. 2 Timothy 3:16–17, advises us that God's word is useful for teaching and training us to be thoroughly equipped for every good work. The Scriptures can show us what love is and develop our ability to love.

God is very serious when he tells us that to love him is to obey him. In Romans 2:8, he warns that there will be *"wrath and anger for those who are self-seeking and who reject the truth and follow evil."* We must choose whether we will follow truth or evil. There is no middle road. God created us. He knows us. He knows how we can live a peaceful and fulfilling life, now. Once we decide to rejoice in the truth, we can learn to love others more completely because we will be holding ourselves to obedience and striving to love others as God want us to love. We will no longer delight in evil, talk about others by gossiping or being divisive. Proverbs 16:28 state: *"A perverse man stirs up dissension, and a gossip separates close friends."* Delighting in evil will destroy love. Let us strive to conquer that sin by committing ourselves to always rejoicing in the truth of God's word.

Love Always Protects—it is not self-seeking

God's love for those who follow him will always be protected. Psalm 37:28 reads, *"For the Lord loves the just and will not forsake his faithful ones. They will be protected forever."* He guards us against Satan's traps and offers us eternal shelter from spiritual harm. It takes self-denial to protect someone else. God sent his only Son to save us from condemnation. In return, we are to love others by denying ourselves for their protection. Philippians 2:3-4 explains this more fully: *"Do nothing out of selfish ambition or vain conceit. Rather, in humility value others above yourselves, not looking to your own interests but each of you to the interests of the others."*

An extreme example of this kind of protection is the story of Bill Quinlin and his nephew David. The two were sailing together and ran into a hurricane which capsized the boat. They were stranded on a life raft with limited rations of food and water. Bill realized that David could survive twice as long by himself, so he unselfishly swam away for the raft without ever looking back. Hopefully we will never be called to a life-or-death decision like that, but we are daily faced with the choice of who to put first, ourselves or someone else. If we are committed to obeying God, the decision is already made, and we will automatically put others first in our lives.

Love Always Trust—it does not envy

Another way we can show our love to God is to completely put our trust in him. There are numerous passages addressing this concept, including salvation. God truly has an unfailing love for us on which we can depend. However, He requires our obedience to His teachings.

Consequently, when two people put their trust in God, they will also have a mutual trust in each other. God is our unifying common denominator. That concept proves true in a Christian marriage. When both partners are committed to living for God, they can be bound together by complete trust, knowing that every step in their lives will be taken to please God and draw closer to Him and our mate.

This loving, trusting bond can be broken by sin of envy (or other sins like immorality). James 3:16 warns that *"where you have envy and selfish ambition, there you find disorder and every evil practice."* People tend to look out for themselves first and feel threatened if someone else is honored or blessed more than they are. Envy is also a consistent partner with selfishness. Sin destroys relationships. We must continually examine our hearts.

For example, two women in our congregation took a Bible class exam which one passed, and the other did not. The decision

was made to give a second test for those who had not passed. The woman who had failed studied very hard and passed the second test with flying colors. Her friend was envious of the opportunity offered her instead of being excited about her learning more from the Bible. Trust cannot exist in a relationship like that. Envy will stop us from being able to love each other, and it will cause severe damage to our overall spiritual condition. Provers 14:30 state that: *"a heart at peace gives life to the body, but envy rots the bones."* In our efforts to learn to love, let us remember that trust in our relationship will bring peace to our lives, but envy will separate us from God and others.

Love—it is not boastful or proud

Another way we can show our love for others is to share with them our hope in the glory of God as Paul did in Romans 5:2b-5: *"And we boast in the hope of the glory of God. Not only so, but we also glory in our sufferings, because we know that suffering produces perseverance; perseverance, character; and character, hope. And hope does not put us to shame, because God's love has been poured out into our hearts through the Holy Spirit, who has been given to us."*

Our hope should be in God who works through any and every situation. We must learn to rejoice through hard times and suffering, standing firm and being confident that our hope in the Lord's will cannot disappoint us. We can then share that faith with others to help them develop a similar hope in God's glory.

For example, the Lloyds recently had a bad fire in their new flat. It was difficult to rejoice as they first encountered the charred remains and considerable smoke damage. But because their hope was in God and not in their possessions, they did not despair. The Lord used that situation for the best, and within months, the wife of the carpet layer had become a Christian.

Many times, though, our love for others can be hindered by being boastful or proud. The Lord declares in Jeremiah 9:23–24,

that we should not boast of our wisdom, strength, or riches but only in the delight of knowing our Lord. Arrogance and boasting are ungodly. When thinking too much of oneself, it is nearly impossible to think about others, to meet their needs and to love them. Let us take Paul's admonition in Galatians 6:14 to *"never boast except in the cross of our Lord Jesus Christ."* Let us keep our focus on the Lord and hope in his glory. Then we will know how to love others.

Love Always Perseveres—it never fails

Diligence is a further demonstration of our love for others. We are taught in James 1:12 that *"blessed is the man who perseveres under trial, because when he has stood the test, he will receive the crown of life that God has promised to those who love him."* We should be grateful for difficult times and pray to learn from them.

We all have difficult times such as family struggles, financial problems, disagreements, people who won't respond to God's word or those who leave the Lord. We also know that many things will fail us in this life-our health, memory, crops, our cars, our friends, etc. But we must stand firm, endure, and never fail in our love for others during those times. We must continue to share our faith with others, teaching them to grow and learning to persevere because of our love for them. God never gives up on loving us. In the Psalms alone, God's "unfailing love" is mentioned 26 times! We likewise should endure trying times and continue to love others as we grow in our faith. Then we will be triumphant. We will be with God for eternity.

Remember Ruth's devotion to Naomi. She was determined to stay with Naomi even until death. That type of devotion is characterized by a love that refused to fail. A sister in London persevered with a friendship for many, many months while the other woman contemplated becoming a Christian. After persistent dedication, numerous phone calls and long discussions,

the woman finally decided to follow Christ. Now they are both devoted workers for the Lord. Who have you recently helped through a struggle? Are you persistent despite opposition and discouragement? We must learn to stand the test and persevere, not failing in our love for others and for God.

God never fails to love us. Growing in our obedience—loving Him—is a life long process.

8

Unity Among Believers

by Gloria Baird

Several years ago, I read a book by Gloria Jay Evans entitled, *The Wall*. The book is a modern parable about what happens when a person builds a protective wall around himself, inevitably shutting other people out in his pursuit of privacy. A great city, in centuries past, would be fortified with a massive wall that surrounded and protected its inhabitants, not from each other but from their enemies.

In this lesson we will learn how Jesus Christ came to break down the first type of wall, a dividing wall of hostility, and to build up the second type, the fortifying wall of unity that will strengthen and protect God's people. We will use the Old Testament book of Nehemiah as the basis for our study.

Nehemiah was a cupbearer to King Artaxerxes of Persia during the Jewish exile. Some men from Judah reported to Nehemiah that the Jewish remnant was in great trouble and distress because the wall of Jerusalem had broken down. He responded by mourning, fasting, and praying to God for help in reuniting the Israelites. God moved King Artaxerxes' heart

to allow Nehemiah to go to Judah and lead the Israelites in rebuilding the wall of Jerusalem. The project which Nehemiah undertook can teach us five keys to rebuilding the wall of unity among believers:

1. Developing the desire for unity.
2. Deciding to strive for unity.
3. Overcoming discouragement.
4. Accepting diversity within the body and
5. Being devoted to Jesus Christ's plan for the body to be united (John 17).

Desire For Unity

Nehemiah's first impulse was always to pray. How powerful our lives would be today if our communication with God was so constant and open before we ever acted on our own or even sought another's advice, we first went to God in prayer, as Nehemiah did in Nehemiah 2:4–5. His prayer to God and brave petition to the King show his great desire for rebuilding the wall of Jerusalem. If God's people are to be united today, we too must have a great desire to rebuild.

I have never been more aware of the need for unity among believers or prayed so much for it as I have this past year. My family went through a major change in 1983. After a fifteen-year membership with the Burlington church of Christ and after much prayer and struggle, we concluded that it was God's will for my husband Al to give up his job as a research scientist and to become an intern with the Boston Church of Christ.

We and others experienced considerable pain as we moved from one congregation to the other. Satan began attacking us on every side, trying to cause division among God's people. I realized that I have taken the bond of unity in the church for granted. As I have personally felt the effects of that unity being shaken, I

have begun to desire the unity that can only come through prayer, Bible study and the power of God working in us to unite us.

Decision to Strive For Unity

Nehemiah's desire to rebuild the wall was followed by a decision: *"It pleased the King to send me; so, I set a time"* (Nehemiah 2:6). We can long for unity, but **unless we individually commit ourselves to striving for it, unity will not be achieved**.

As soon as Nehemiah decided to rebuild the wall, his enemies began plotting how to stop the work. Nehemiah 2:10 records that Sanballat and Tobiah *"were very much disturbed that someone had come to promote the welfare of the Israelites."* How similar that is to our enemy, the devil, when he sees us rebuilding the wall of unity. Only a resolute decision to stand firm and persevere will enable us to overcome the many attempts by Satan to hinder our efforts. The Jerusalem wall reached completion because Nehemiah's desire was solidified by decision.

One of the first things Nehemiah did when he arrived in Jerusalem was to inspect the broken-down wall for needed repairs. In our rebuilding quest, we need to decide in what ways the wall of unity is broken down in the church of Christ. There are divisions over such issues as Sunday school, the Holy Spirit, music, and co-operation. These are opinion matters. Not biblical doctrine. Within individual congregations, is there competitiveness, lack of relationship and respect that are causing division? What is breaking the wall of unity? Opinion matters should not divide us. God's word should unite us, and it does. We need to be like Nehemiah and **pray and decide** to build our unity (John 17). Jesus prayed for this just before the Cross.

In addition to committing himself to the work, Nehemiah called on others to join him. The Israelites agreed to help and Nehemiah 2:18 records that *"they began this good work."* We must see the vital need for unity among believers and consider it as a good work. We cannot afford to have an attitude of indif-

ference but must decide that unity will be as important to us as it was to Jesus in his prayer in John 17:23: *"I in them and you in me—so that they may be brought to complete unity. Then the world will know that you sent me and have loved them even as you have loved me."*

Discouragement

Nehemiah 4:10–12 describes a problem common to any great work-discouragement from within. The people of Judah began complaining that *"the strength of the workers is giving out, and there is so much rubble that we cannot rebuild the wall."* The Jews who lived near them added ten times, *"Wherever you turn, they will attack us."*

Women are especially prone to this problem because we have a strong influence on strengthening or weakening the body of Christ. Most of us can cite instances in which the work of a godly man was adversely affected by the bad attitudes of his wife. Considering the weight of responsibility our men carry in the church, the last thing they need is for their wives to unload all their hurt feelings and worries on them. I challenge each of us to personally commit herself to praying first and then putting Matthew 18:15–17 into practice—go directly to the person with whom you have a problem rather than complaining to someone else.

Nehemiah responded to the discouragement of his people in a godly manner. He stationed the Israelites by families at various places and encouraged them about the enemy attacks: *"Don't be afraid of them,"* he said in Nehemiah 4:14: *"Remember the Lord who is great and awesome."* He gave each person responsibility but pointed him to his power source. Note that each family was not working on guarding their own individual part of the wall. Rather they were all working together for the rebuilding of the whole wall.

In the church, we urgently need to regard the full picture of the kingdom of God rather than seeing one side of it from our

isolated, restricted viewpoint. We are to be stationed at every point to build up the church universal. Our view and concern should not be limited to just the church in our region of our nation. Paul called the Corinthians to be united and not to follow different personalities: *"I appeal to you, brothers, in the name of our Lord Jesus Christ, that all of you agree with one another so that there may be no divisions among you and that you may be perfectly united in mind and thought"* (I Corinthians 1:10). Sometimes we think this includes matters of opinion. It applies to the teaching of the Bible, not opinion. Opinion divides us.

Nehemiah acknowledged the difficulties in the work, but he also gave solutions. In Nehemiah 4:19–20, he said, *"The work is extensive and spread out, and we are widely separated from each other along the wall. Wherever you hear the sound of the trumpet, join us there. Our God will fight for us!"*

That is especially meaningful to me as I think of some of my dearest brothers and sister who are in Burlington, Texas, New Mexico, and California. The sound of the trumpet reminds me of the ring of the telephone. What a blessing it is to be able to keep in touch with one another no matter how many miles apart we are. I remember a phone call from a friend in Texas who was preparing a class on faith and wanted to share ideas on that subject. Another person called needing comfort and direction during a painful family crisis. Other calls come from Christians around the world sharing their struggles and victories in their walk with Jesus. How important are those calls to reaffirm our love for each other and to help us overcome discouragement?

When the enemy further insulted and ridicules the Jews with such undermining questions as "Will they do it?", "Can they finish?" and "Will it last?", Nehemiah and the people responded by praying to God and working with all their hearts (Nehemiah 4:4–6). They overcame discouragement by dedicating themselves to God and his work and then proving their dedication by their actions. As was seen in the early church in Acts, persecution

intensifies zeal and fervor and encourages unity: *"All the believers were one in heart and mind"* (Acts 4:32).

Sanballat and Tobiah well understood the value of unity. *"They all plotted together to come and fight against Jerusalem and stir up trouble against it"* (Nehemiah 4:8). Again, Nehemiah prayed to God and posted a guard day and night to meet the threat. That example shows us the necessity of being on constant guard against our enemy, Satan and of protecting each other's weak side. Our strength as a body will increase as we strive to be filled with God's Holy Spirit and to be "our sister's keeper". Instead of picking each other apart, let us encourage and build each other up in love, as God commands. That is what he does for His church when we are unified.

Diversity

Another important aspect of the rebuilding work is seen in Nehemiah 4 and 5: the diversity of roles and needs. The work of the people varied. Some did the building, some guarded the workers, and some carried materials, and some feed the workers and took care of their daily physical needs. All the men were armed with swords, ready to resist those against them.

The unity we are to have in Christ is not based on sameness but on oneness Ephesians 4:11–13 describes the various roles needed to prepare god's people for works of service to build up the body of Christ so that all will reach unity and maturity. Galatians 3:28 encourages us to see the emphasis of our oneness in Christ: *"There is neither Jew nor Greek, slave nor free, male nor female, for you are all one in Christ Jesus."* Too often we emphasize our differences, letting them divide us rather than being called to unity. God's unity is built when we work as a team.

Keep in mind that all the Israelites were armed with swords. Likewise, each of us must be armed with our "sword"—the word of God and God's gift, our talents and strength. There is no substitute for individually drawing upon the power of prayer and

God's word and equipping ourselves for the constant battle with our enemy. The commitment needed is illustrated in Nehemiah 4:23: *"Neither I nor my brothers nor my guards with me took off our clothes; each had his weapon, even when he went for water."* The Israelites realized the strength of their enemy and that they could never let down their guard or go on vacation. They had too always be alert and armed. How much more that attitude applies to us today as we fight against Satan.

The needs of God's people vary. Nehemiah 5 describes the different physical needs for food, property, and financial resources. The unrest and complaining brought about by those needs not being met had an adverse effect on outsiders as indicated in Nehemiah 5:9: *"Shouldn't you walk in the fear of our God to avoid the reproach of our Gentile enemies?"* When we fight among ourselves, we give the unbeliever the right to reproach us. As John 13:35 declares, we will be known as Christ's disciples by our love one for another. If we are not caring for the physical needs withing the body, that love is not evident to outsiders.

A family in the Boston congregation recently lost their home and belongings in a fire. Christians worked together to provide financial help as well as food, furniture, and clothing. Members of the Burlington congregation raised a special contribution to buy an elevator for a child in a wheelchair, then put in many hours to work to install the elevator. When the Christians in Poland needed food and other supplies, congregations around the world responded with great generosity. God was pleased!

The value of meeting the physical needs of others should never supersede the importance of meeting the spiritual needs of our brothers and sisters in Christ. There is a tremendous need in the body for close relationships characterized by openness and mutual encouragement. Hebrews 3:13 exhorts us to encourage one another daily. Hebrews 10:24 commands us to *"consider how we may spur one another on toward love and good deeds."* Our communication with each other should be direct, speaking

the truth in love (Ephesians 4:15). A dear sister shared with me that I need to be responsible for what a person hears me say. That concept helped me communicate better and become more careful with my words and their impact.

The third chapter of Nehemiah describes the various sections of the wall that were worked on by specific people. The work was not a one-man job but a task that required individuals to labor together. Team spirit is essential in the church, which is a body composed of many members, each doing their part and showing concern for others (1 Corinthians 12:12–27).

There is plenty of room withing the church for different methods of accomplishing God's work. There is no room for discord due to personality clashes, prejudice, hurt feelings and vying for leadership. We desperately need to value the function of each member as he is empowered by Christ.

Ephesians 4:16 states that from Christ *"the whole body, joined and held together by every supporting ligament, grows and builds itself up in love, as each part does its work."* Nehemiah 3:5 notes that some of the Israelites did not do their work: *"their nobles would not put their shoulders to the work under their supervisors."* Sometimes we feel certain tasks are too menial for us or that someone else should do the job. Each of us needs to be willing to serve in whatever way we can.

Another point in that verse is that the nobles would not work under their supervisors. Unity cannot exist where there is a lack of respect for authority. God's plan for his people involves leaders and followers. Hebrews 13:7 directs us to *"obey your leaders and submit to their authority. They keep watch over you as men who must give an account. Obey them so that their work will be a joy, not a burden, for that would be of no advantage to you."*

1 Thessalonians 5:12–13 further instructs us *"to respect those who work hard among us, who are over you in the Lord and who admonish you. Hold them in the highest regard in love because of their work."* Nehemiah's response to his enemies,

always spoken in faith was, *"the God of heaven will give us success."* He was confident God would bless the efforts of the people because they were busy doing God's work. We too can be confident that God will bless our efforts if we continue striving for unity and do not let diversity cause us to fall.

Devotion

Another quality of Nehemiah that we need to emulate in our rebuilding of unity is his devotion to the work. Nehemiah didn't lord his leadership over people nor was he proud or concerned with position. He didn't use his leadership to acquire material gain and fame but single mindedly sought the good of his people by rebuilding the wall. His right actions stemmed from his reverence for God (Nehemiah 5:16) and devotion to his work.

Nehemiah's enemies attempted to distract him from his work by saying, *"Come, let us meet together."* They knew that if they could sidetrack the workers and cause them to compromise, the wall would be left unfinished. Unity is not brought about by compromise saying, *"peace, peace where there is no peace"* (Jeremiah 6:14), but by being devoted to the true peace found only in Christ. Ephesians 2:14–18 beautifully describes that peace and unity.

The enemies of Nehemiah next tried false accusations in the form of an unsealed letter. The danger with false accusations is that they tempt us to defend ourselves and so be sidetracked from the work we need to be devoted to doing.

Scare tactics are also commonly used by the enemy. Nehemiah's foes taunted him by saying *"Their hands will get too weak for the work, and it will not be completed"* (Nehemiah 6:9). Satan fed me that same line as I worked on this lesson, tempting me to fear that I wouldn't be able to put it together in a meaningful way. Nehemiah's response was to pray for God to strengthen his hands. I experienced that same strengthening as my husband and daughters helped in some concrete ways so that I could devote

my time to accomplish God's task.

Finally, Nehemiah's enemies tried to lead him into sin so that he would be discredited. They intimidated him through the nobles of Judah who were under oath to Tobiah and had to keep corresponding back and forth with the enemy. The nobles became middlemen relaying information. We should be wary of such second-hand reporting because it usually distorts the true picture. Human nature tends to believe the worst rather than think the best.

I remember a time I got a second-hand report about a Bible class taught by a friend. It was noted that few scriptures were used. I was amazed and quickly became doubtful about the class instead of maintaining my confidence in my friend. When I received the direct report, I learned that my friend had prepared too much material and had already made plans to share the rest of the information at another time. If we are to be unified, we must believe the best and be devoted to seeking the truth in all things.

When the work on the Jerusalem wall was completed, Nehemiah's enemies lost their self-confidence because they realized that the work had been done with the help of God (Nehemiah 6:16). If we are to complete the work God has for us and have victory over our enemy, the devil, we must believe the reality of Christ's prayer in John 17:20–26 and be devoted to becoming one as Jesus and the Father are one (verse 22).

The actions of the people following completion of the wall give us one last parallel to unity. In Nehemiah 8, the people gathered to praise God and hear the reading of the Book of the Law. They feasted and celebrated with great joy, sharing with those who had nothing prepared. They were told to proclaim God's word throughout their towns.

As we feast on the blessing of unity in Christ, we too should be sharing and proclaiming with others the good news that Christ has broken down the dividing wall of hostility through his death

on the cross, enabling mankind to truly be one. Paul attested to the great joy that comes from sharing the gospel: *"How can we thank God enough for you in return for all the joy we have in the presence of our God because of you?"* (1 Thessalonians 3:9).

God's desire throughout the ages has been for his people to be united. Jesus warned us that every kingdom divided against itself will be ruined (Matthew 12:25). If the church is to be successful in its mission, it must start rebuilding the wall of unity with the building blocks specified in God's word. The oneness described in Ephesians 4:4–6 comes when we clothe ourselves with *"compassion, kindness, humility, gentleness and patience."* We must "bear with each other" and forgive whatever grievances we have against one another, forgiving as God has forgiven us. Over all those virtues, we must *"put on love, which binds them all together in perfect unity"* (Colossians 3:12–14). God's church will be united only to the degree that each of us individually takes up this good work. As we continue to pray for unity as Jesus did, may our hearts be filled with a deeper desire for God's people to be one. May each of us decide to be dedicated to this effort, resisting the discouragement of the enemy. May we be fully devoted to God, his word, each other, and those around us who are ignorant of true unity. Then we will be able to say with the Psalmist David: *"How good and pleasant it is when brothers (and sisters) live together in unity!"* (Psalm 133:1).

2022 addendum. Al and Gloria were our closest partners in the gospel. She is smiling from eternity that this book is being reprinted. In 2018, I spent the last few hours of her conscience life on earth with Gloria and her family. It was my blessing from God. When I see her again, I can't imagine what it will be like. God's victory in our lives was love and unity. I can never remember our friendship being threatened by disunity or conflict. We shared God's vision. I remember us helping to build the wall together. I pray you have these blessings.

9

Unity in the Family

by Carmen Bentley

We live in a time when families in the world are struggling and dying because they lack unity. As Christians, we cherish the unity Jesus came to bring and died for us to have as families belonging to him. We long to extend this to others. It is so powerful and motivating to know that as Jesus faced the cross, he prayed to the Father for unity, among his people, which includes our families. John 17:20–23 reads:

> *"My prayer is not for them alone. I pray also for those who will believe in me through their message, that all of them may be one, Father, just as you are in me and I am in you. May they also be in us so that the world may believe that you have sent me.*
>
> *I have given them the glory that you gave me, that they may be one as we are one—I in them and you in me—so that they may be brought to complete unity. Then the world will know that you sent me and have loved them even as you have loved me."*

Jesus' plan is for a "oneness" and "complete unity" in the church and in our homes. He wants us to shine out to a dark, lost world and draw it to himself. We realize that Jesus is very serious about us being united, and out of our love, honor, and respect for him, we long for his unity! In this chapter we are going to discuss unity in our families:

1. What is unity?
2. How does our relationship to God affect our unity?
3. Family characteristics that glorify God.
4. How we can use family hospitality to help brothers and sister draw the world to Him.

What is Unity?

As we look to God's word for a definition of unity, we learn that God wants us to be united in our effort to obey Him as defined in **His Word.** Obedience to God is where we begin. Faith in Him as our creator and Christ as His son. Our children do what we do. As we teach our children to obey their parents, we begin to teach them about obedience to God. God says that the husband is to be respected and obeyed by his wife and children, if he doesn't oppose God. Children are to respect and obey their parents. Parents are to teach their children to revere and obey God, daily. John 17:21–23 teaches that our family and the family of God (the church) should be united as they teach obedience to God. 1 Corinthians 1:10 teaches that we shouldn't be divided, but be perfectly united in mind, and thought. Ephesians 4:3 states that the unity we have through the Holy Spirit has brought about peace with God and peace with one another. We need to make sure that we have allowed God's definition of unity to be our standard and not the world's shallow understanding which consists only of co-existing under the same roof and doing our "own thing" without concern about how we respond to God. We must be determined to come to God on his terms and to learn how to have the unity that only he can bring about in our families.

Our Relationship to God and Unity

The foundation of family unity is our personal and family relationship to God. Psalm 127:1 says: *"unless the Lord builds the house its builders labor in vain."* We are familiar with this passage, and we say we believe it, but are we living it out in our lives? We need to be determined and consistent about studying God's word daily and applying it to our lives. We need to let it teach us how to think, act, speak, love, etc. The Word tells us how to teach our children and those that don't know God yet. As we pray daily to constantly allow God's power to change us to become and do the things, he has purposed for us.

In our family we pray together daily and have a set time once a week for a family devotional. Since our children are young, ages four and two, our devotions only last about 15 minutes. My husband and I select a topic that we believe will teach our children about God, attitudes he wants us to have and how he wants us to behave. We focus on one scripture. We conclude in prayer. For example, a devotional we had on *"doing everything without grumbling and complaining"* began with a short skit in which Daddy was the little boy grumbling and complaining about being disciplined (Philippians 2:14). We talked about the boy's attitude and behavior, and then the scripture and how God wants us to respond. We all committed the verse to memory, then wrote the scripture reference on a star for each of the children. They put the stars on the refrigerator with magnets, and we remind each other of it often! Some families in our congregation with older children have family devotionals daily with different family members taking turns leading them. We need to always remember that without the daily abiding in Christ personally and as a family, we can do nothing (John 15:5).

Family Characteristics That Glorify God

John 15:5-8 brings us to our next point: abiding in Christ as a family result in bearing much fruit which glorifies God and

shows that we are truly Christ's disciples. Satan places a temptation before every family, that of using our family as an excuse not to go out and make disciples as we are called to do in Matthew 28:19–20. The thoughts run through our minds.... We have more responsibilities now that we are married and have children. "We just don't have time to be like Jesus anymore." Yet our families are one of the greatest blessings that God has bestowed on our lives and ought to be the light of the world, the city set on a hill (Matthew 5:14). The way we love, serve, sacrifice, and teach others about God ought to not only stagger the world, but draw them like a magnet (John 13:3).

Our families need to develop the following characteristics to draw others to God:

- Love, devotion, and zeal for God. (1 Thessalonians 1:3).

- Love one another (John 13:34).

- Openness in communications, speaking the truth in love (Ephesians 4:15, 29).

- Humility in confessing sins (James 5:16).

- Forgiving one another as God forgives us (Colossians 3:13).

- Purity and godly wisdom (James 3:13–17).

- Personal discipline and discipline of our children (Ephesians 5:15).

Our family takes Philemon 6 seriously: *"I pray that you may be active in sharing your faith, so that you will have a full understanding of every good thing we have in Christ."* We have a time set aside every week to go and meet new neighbors to share our faith with them and invite them to church and to the evangelistic Bible study in our home. We also make it a point to pray together before we go out. We have had several neighbors

become Christians, and several more are now attending the Bible study in our home and are studying to become Christians. One of the great joys in our marriage has been for us to study with other couples together that we've met either door-knocking or in recreational activities. My husband has met men in the archery shop who he's shared with and invited to church-related activities. We were able to build a friendship with one of those couples. They studied the Bible with us and obeyed the gospel. There are other couples now attending our study. I joined a tennis league about two years ago through the encouragement of a sister in Christ who is my doubles partner. Joining the tennis league has been a great opportunity for me to meet women, build new friendships and share my faith. My husband and I have helped one of those women and her husband to become Christians, and there are several other women attending one of our daytime evangelistic Bible studies.

As a family, we have a goal to share with everyone we meet. One of our grocery stores clerks has responded to the gospel, and a bag boy is presently attending the study in our home. God has blessed our family unity in great ways because of sharing our faith in this way. The common purpose, the prayer and creatively working hard together and seeing God work to produce new Christians is a tremendous joy!

Another great result is the discipling of our children, teaching them in word and in deed what it means to abide in Christ, to love God and his word, to go make disciples, to love people, to bear much fruit and to glorify God in that way.

Hospitality as a Family

Lastly, we want to look at hospitality, a tremendous tool that God has given us to affect and draw the world to him. We are called in Romans 12:13 to *"share with God's people who are in need. Practice hospitality."* It's great for our family unity to open our home and share with brothers and sisters what God

have blessed us with. We desire to be *"devoted to the fellowship"* (Acts 2:42). We want to be generous, friendly, encouraging, up-building, and example and to learn from other Christians. We've found that our home is one of the greatest places not only to love and disciple our children but also our brothers and sisters as well (2 Timothy 2:3). Christians are consistently invited over to our home to pray, study together, share with non-Christians, set goals, eat, and just enjoy being together. We can see our children growing in their love for other Christians and growing in their excitement about spending time together.

We are also given another example of hospitality in Acts 18:26 when Priscilla and Aquilla invited Apollos to their home to *"explain to him the way of God more adequately."* That kind of initiative tells people we care, and we are concerned, *"We love you so much that we are delighted to share with you not only the gospel of God but our lives as well"* (1 Thessalonians 2:8). About 95% of the non-Christians that we have had in our home for meals and have loved and shared with as a family have be-come Christians. We give God the glory and praise for that and thank him in a special way for blessing us with a family that is striving to be united in him, striving to please him and to bring as many people as possible to him.

We realize that we can't be selfish with our families. They belong to God. He blessed us with them. We've discovered that family unity is the result of an individual and collective rela-tionship with God. Our love for each other and the church and our zealous outreach to the lost is also a blessing from God. Our family is not neglected, but unified and built up when we are serving the Lord together. We are so blessed, at peace and joyful.

10

Single Christian Households

by Donna Western

For the single Christian woman "making it" often means having roommates. We learn about ourselves when we have roommates. The high cost of living alone, coupled with the desire to grow spiritually has led many to form households of unrelated adults who share their lives alone with their expenses. Jesus lived with the apostles to teach them. When we live with others, we learn what we need to change to be more like Christ. It isn't always easy.

This chapter is for all who long to have a positive, up building spiritual home life. No magic answers, only scriptural solutions, and experience-based suggestions of what a home can and should be. My past struggles in this area have taught me many lessons on what makes a roommate situation a spiritual, learning experience. Having lived as a wife with my own house and later as a single with my own apartment, it was a major decision and change for me to move in with sisters. My first experience was difficult. But, for the past year, I have been happily residing with four sisters in a four-bedroom, one bath house. It has gone great.

As in our relationships, the joys and rewards of roommates are found by focusing on how much one can give, rather than on what one expects to receive. Loving service is the heart of Christ's example and teaching on interacting with others. To apply that concept to our daily lives, we will examine four ways we can give to our roommates:

1. God-centered priorities and actions. (Philippians 3:8,9)
2. Praying & taking initiative in a godly way. (Proverbs 31)
3. Victorious Roommates. (Philippians 4:11)
4. Encouraging Roommates. (Philippians 1:25,26)

God-Centered Priorities and Actions

Paul's attitude in Philippians 3:8–9 sets the foundation for successful roommate relationships: *"What is more, I consider everything a loss because of the surpassing worth of knowing Christ Jesus my Lord, for whose sake I have lost all things. I consider them garbage, that I may gain Christ and be found in him, not having a righteousness of my own that comes from the law, but that which is through faith in Christ—the righteousness that comes from God on the basis of faith."*

Are you concerned with losing the things of this world to seek the righteousness of God? Are your roommates concerned in this way? God does not put people together haphazardly. You are with your roommates for a purpose, to teach one another how to be more Christ-like. Remembering that God is your planner so that you can become more like Christ can alleviate the difficulty of sharing one's possessions and submitting to one another out of reverence for Christ (Ephesians 5:21).

If your household is a pit stop instead of a home and if there are personality differences (sin?) between roommates, then God is not at the center of your relationships. A right household begins with each roommate having a relationship with God. Praying together is very helpful, not just at meals. Accepting that you are one another's "keeper" and best friend helps us achieve a mutual-

ly encouraging relationship. A household that brings each roommate closer to God and each other is the goal. Christ's prayer for unity emphasizes (John 17:21) that the world will know we are his disciples if we are united in Him.

In my household, our goal as roommates is for each woman to help the others have and keep God as the center of our lives and in our home. We strive to communicate with each other, to keep in touch about people we're sharing with, how our Bible study has helped us, the defeats, and victories of our daily lives. Once a week, we take the time to sit down, pray together and catch up with each other. Our unity and individual maturity have grown as we have made the effort to really listen to each other and help ensure that Jesus is Lord over our minds, moods, minutes, and ministries.

Praying and Taking Initiative in a Godly Way

Another example worthy of imitation by roommates is the Proverbs 31 "wife (friend) of noble character." She possessed a lifestyle and many qualities that single women need to develop a positive Christian household. Note how the scripture stress's her eagerness and enterprise. Her eyes were set on seeing what needed to be done, and her hands were always ready to act.

Roommates can be separated into two general groups: those who take initiative and those who don't and are waiting to be asked to do something. Which group describes you. The Proverbs 31 woman took initiative to serve others. Another way is to discuss a list of chores together and determine who wants to do what to keep things in order. Then, the responsibilities taken can be completed with unity and teamwork.

It is a great blessing to be part of a household where all members take responsibility for keeping all rooms ready to receive a visit from Christ, or an unexpected visitor. I remember the time our shower needed a repair. The part cost 65 cents. The need was evident, but I didn't have time to meet it. I came home

one day to find the shower fixed. I was so grateful. My roommates also worked out a schedule for emptying the dishwasher so that dishes didn't accumulate in the sink. What a joy for all of us.

Taking initiative is an upward call to everyone around you. If one roommate takes initiative others will do the same. The opposite us also true. A dirty glass in the sink can lead to a mountain of dirty dishes—which depresses everyone. We share responsibility for household tasks and rotate responsibilities so that each of us can be trained in all the areas. Daily, we maintain a "straightening up" of community spaces. Everyone keeps their bedrooms orderly daily. We try to always keep our home presentable to Jesus.

Initiative is also expressed in learning to say what's on our mind and not expecting our roommates to be clairvoyant. Self-pitying moods of feeling our needs are "not being met" can be eliminated by simply verbalizing needs.

Likewise, an initiating roommate will grow in her ability to understand her sisters so that she can tell when something is wrong. Sometimes a person doesn't know how to express their feelings. If a roommate stays in her room for three days, what will you do? Respect her privacy or know she needs help of another sister? Train yourself to recognize potential trouble and then take steps to change the situation. I call that "walking and talking through."

The need for initiation can be summed up in your answer to this question. Do I want my household to be like Jesus? Successful roommate living, like marriage, requires giving by everyone. When someone is unwilling to come to you, go to them (Matthew 18:15). Keep alert to ways you can help, both spiritually and physically. The result will be worth the effort.

Victorious Roommates

Our roommates are the people who know us best and can therefore help us the most to grow spiritually. They see us as

we really are and so can help us recognize our talents and our weaknesses (sinful natures). Do you view your household as an opportunity for spiritual growth and victory? Are you expecting victory in your roommates' lives, helping them to be their best? Are you running to win a crown for yourself, being open about your life and allowing them to help you grow? Are you laughing together and having fun times, as well?

One essential area roommates must be victorious is their daily communication with each other. In my household, that means leaving notes in a central area to guarantee a response, each roommate initials are made at the bottom of the note, so all know who understood it. We also strive to come home after work and be outward and positive rather than focusing on our fatigue. I have had to learn not to walk in with the mindset of "I have a lot to do." How we greet each other at that time can set the tone of our relationships.

Good communication takes work but is a light to those involved. As Christians, we go beyond the superficial reporting of events and share our defeat, victories, sorrows, and joys. Roommates can be some of our closest friends as we work together as family to meet one another's needs. Concentrate on one another's strengthens not their weakness.

Developing a family-like atmosphere is another victory for all involved. We all come from different families and backgrounds. Some new Christians didn't come from loving families and have no positive blueprint. Our concern for and interaction with each other should demonstrate to others that we belong to the family of God. Being single, means we have more unstructured time than our married sisters with children. We shouldn't use our flexibility to neglect but to use our home, offering hospitality and serving others as family.

My household has decided to cook dinner at home every night. Everyone signs up for a night, chooses the menu and cooks. It is a wonderful, warm feeling to come home from work

and catch a terrific aroma wafting down the stairs. We also do household chores together, making the mundane a time of fellowship and fun and enjoying the outcome.

Perhaps the greatest victory in our household, personally, has been adopting the attitude of Paul in Philippians 4:11—*"I am not saying this because I am in need, for I have learned the secret of being content, whatever the circumstances."* This translates into "Yes, I'm 30 and sharing a house with four other women, and yes, I'm going to be okay." I had to realize the benefits of having roommates, to take an unnatural situation and make it natural without getting upset over small things.

A small thing. I have slept on a big bed, all my life. When I first moved into my present household, I had my own room and was able to keep my antique full-size bed. Then a recently divorced sister became one of our roommates and needed to have her own space. I gave my room to her and began sharing a bedroom with another roommate. My antique bed had to go into storage. I had to adjust to sharing a room. It was difficult for a while, now my roommate is one of my best friends and I don't give it a thought.

Being content means deciding to make the best of wherever you are, to stop living in the future and pining for marriage. I have learned to be content sleeping on a borrowed bed and using someone else's furniture while my own possessions remain in storage. The victory of learning to be content in any circumstance has made the present a joy not a burden.

Encouraging Roommates

The apostle Paul's relationships abounded with encouragement. In Philippians 1:25–26, he wrote his brothers and sisters in Philippi that *"I will continue with all of you for your progress and joy in the faith, so that through my being with you again, your joy in Christ Jesus will overflow on account of me."* Does your roommates' joy overflow on account of you? We all need

encouragement to be encouragers. That area of giving can be expressed in many ways, depending on the needs of those around you. When my schedule gets too busy and there's no time to do laundry, it really encourages me to find that one of my room-mates has done it for me. One time I came home from a partic-ularly hard day and was encouraged to hear that my roommate had initiated a Bible study with our neighbor. That kind of news shows me there is joy and progress in our faith.

Encouragement comes from fulfilling a need without being asked and from caring enough to help your sister be her best. My roommates have encouraged me lately by prompting me to diet and exercise more so that I can look my best. Striving to help each other me more feminine is a part of our spiritual ministry, in my opinion.

To find out if you are an encourager or a discourager, ask yourself if you:

1. Act like you enjoy living here.
2. Honor your roommates' time alone with God?
3. Respect your roommates' privacy and property?
4. Empathize with what kind of day she has had?
5. Actively look for ways to serve them?

I thank God daily for my roommates. They have given my great joy. If you need to change anything, I pray that today, you decide to change individually so that your household may change collectively and glorify God with its loving, Christ-like giving.

11

Spiritual, Fun-loving Teens

by Adrienne Scanlon

In America today, over one-third of all teenagers use illegal drugs. Approximately 20% of high school seniors are using marijuana every day. I learned those startling statistics from a pamphlet put out by Pharmacists Against Drug Abuse. The pamphlet stated that by the time children complete elementary school, they have had to make a yes or no decision about marijuana.

The statistics about the sexual activities of our youth are just as devastating, along with their seemingly crazed devotion to contemporary rock starts. The saddest part of this picture is that all the partying, sexual encounters and rock and rolling is done in the name of **fun.**

Having fun has become the most important aspect of a teenager's life. They are all searching for it, trying various ideas of fulfillment, and repeatedly coming up empty. As a teen counselor for the past three years, I have seen that many of these searching teenagers do not consider looking to God as a possible answer to their questions. Christianity is viewed as limiting, unexciting and not fun.

I believe with all my heart that teens can be spiritual and have fun. My experience with teenagers has shown me that the kind of fun they are looking for is primarily associated with freedom; they want the independence and status of an adult. Specifically, teens desire the freedom to:

- Face the world on their own
- Reject authority
- Explore new horizons
- Express their opinions
- Decide who their friends will be
- Organize their own activities and
- Mold their own characters.

We will look at each of these desires for freedom individually.

Face the World on Their Own

Independence is the main desire of the teenager's heart. Unlike the little child who constantly clings to his parents and feels their protection and guidance, the teenager resents the sometimes-smothering love of his parents and rejects their advice. They believe the time has come for them to make their own decisions, establish a personal identity, and solve their own problems. Most teens begin this stage of their lives with high ideals and a sincere heart but end up with shattered dreams and a disillusioned, confused sense of right and wrong.

The "fun" starts when teens begin to test their independence. They push their parents to see how far they will bend before they snap back and "lay down the law". It becomes an unconscious a game. Parents get one-word answers from their children, truth gets twisted and stretched until it is unrecognizable. And the secret life of the teenager is born.

Two years ago, I was studying the Bible with three friends of one of the members of our youth group. One afternoon when I and the Christian teen were studying with the other girls at their home, we found them very quick to sit us down and get started on the study, asking several times when we planned on leaving. The girls were usually very hospitable and talkative, so I asked what the matter was. They mumbled for a while, then admitted their mother was coming home from work early and didn't know they were studying the Bible.

Although I had frequently asked the girls if their parents approved of the Bible studies, they had been determined to do it their way, independently of their parents. I waited at their house that day until their mother came home, then introduced myself and my purpose. She had no objections and all three of her daughters are now Christians.

Some teens do not fare as well in their search for independence. By the time they realize that the world is lonely and empty without those that love them the most, it is too late to repair damage that their "fun" has done to their family relationships. God gives us three commands that will prevent that alienation:

1. **Honor you parents.** The typical teen response to God's command in Ephesians 6:1–3 to honor and obey your parent is "What if they are wrong or I disagree with them"? If you feel that way toward your parents, the most important thing to do is to reason with them, respectfully. Express your point of view, calmly and prayerfully, and help them understand your perspective. Parents can't make valid judgments or give sound advice if they don't have all the facts and all your feelings are known. When you have put everything in the open, then decide that you will trust their decision and obey them. If you do, God promises it *"will go well with you and you will enjoy long life."*

2. **Tell the truth.** God repeatedly warns us that deceit is a sin. An Acts 5, Ananias and Sapphira fell dead after they lied because God decided to take their lives due to their sin. Several years ago, I worked with a teen who had a serious problem with telling lies, exaggerating stories, and deceiving others. One afternoon I picked her up after school and found her unusually quiet. Three blocks away from the school, she started crying and explained that one of her non-Christian classmates who had visited the church several times was spreading lies about the church and her. I stopped the car and used the opportunity to help her see how hurtful lying and storytelling can be. We looked at the Bible together, had a prayer, and she has been victorious over the sin ever since.

3. **Take advice.** God encourages all of us, both young and old, to take advice (Proverbs 12:15, 19:29, 20:18). Without counsel, our plans and actions may wind up failures. Although it may not initially seem like much fun to obey our parents, be honest all the time and seek advice, the result is that we are always victorious (2 Corinthians 3:18). It isn't fun to damage our family relationships or to hurt others with our lies or to fail at our goals. It is fun, to communicate, trust and grow in our love and respect for our families as we begin to face the world for the first time on our own.

Rejecting Authority

Authority-parental, academic and legal-seems to dominate a teens life. It becomes cool to go against authority by using drugs or breaking school rules and getting away with it. There is an immediate thrill that comes with a marijuana high and a successfully cut class. Of course, it is more fun to hang out with the

gang than to sit through a chemistry lecture. However, when the college rejection letters begin to arrive in the mail and someone in the senior class dies because he was driving home drunk after a dance, regret is there.

To pass on the immediate thrill to have the joy of a healthier, stable life seems logical. I have watched over twenty teenagers from our youth group graduate from high school with honors and go to college – secure and happy with who they are. The key to their success is:

1. They submitted to God's plan as adults (Hebrews 13:17).

2. They submitted to legal and academic authority. (Romans 13:1).

3. They worked hard (Colossians 3:23).

The fun they had in high school came from their relationships with each other and from the fact that they had nothing in their lives to be ashamed of. They now have the joy of looking back at their high school days without regret.

Explore New Horizons

Unfortunately, most of the horizons the world has to offer are devastating to young minds and hearts. Disillusionment from discovering what the world is really like can destroy a teen's desire to keep searching for and trying new things. There are few situations sadder to me than finding a high school student who has already given up the search.

God promises that when we seek him, we will find him (Matthew 7:7–8) and that he has a hope and a future planned out for each one of us (Jeremiah 29:11–13). One teen I studied the Bible with had a deep understanding of this search for God. She had come from a very sheltered home with little chance for emotional expression or close family fun. She became a Christian

because she wanted her life to count for something. Within one year after her conversion, five of her friends had come to know Christ also. More than any other teen I have worked with, she realized that the exploration of new horizons is a fun and exciting adventure if you look in the right place and continue to share with others the answer you find.

Express Their Opinion

The freedom that teens like the most is being able to express their opinions. It is amazing how many sixteen-year-olds are sure they know how to do everything better than an adult. It is equally amazing how many have one opinion on Monday and a different opinion by Saturday.

Having opinions is fun for teens because they love to act based on their opinions, proving themselves right and everyone else wrong. Teens need to discuss their opinions. These opinions should be calmly countered when they are incorrect and ungodly to protect them.

God has given us a way to avoid embarrassment when we are wrong and humiliated. John 8:31–32 teaches that if we put the word of God into practice in our lives, we will know the truth and be set free from sin and guilt. The result of having our attitudes and opinions always in accordance with God's word is that we will never have to fail or be embarrassed in front of anyone.

During the teen years when opinions and attitudes are in a formative stage, the Bible can be a stabilizing influence in a youth's life. When teens realize that the Bible can help them form and express opinions with confidence, it is fun.

Decide Who Their Friends Will Be

I Corinthians 15:33 warns the *"bad company corrupts good character"* whereas Colossians 1:28–29 shows that devotion to Christian relationships produces a godly character within us. The peer influence on a teenager is stronger than that of his parents,

his teachers, or his youth minister. Several of the members of our youth group shared with me that their greatest source of fun is their relationships with one another. The strongest relationships they have are outside their homes with other members of the youth group who they know will help them grow closer to God. Many of their non-Christian friends at school have recently been drawn into the youth group because they can see the deep and positive relationships that are there (John 13:34–35). Finding the friends that are going to lead you closer to God rather than draw you farther away is the key to having fun and long-lasting relationships.

Organize Their Own Activities

I can remember beginning to resent, as a teenager, the family outings to historical sites that my father enjoyed, and I did also as a child. Teenagers are full of energy and always looking for ways to channel it. They like to plan their own activities but, once again, will often become involved in unhealthy and unproductive plans it left to their own resources.

2 Timothy 2:2 teaches that responsibility must be entrusted to reliable people. Teens must be trained. In our youth group we have several teens who participate in the planning and organization of the group's activities, we expect these teens to be faithful with the tasks given to them, and we train them how to put Matthew 25:23 into practice. The group activities are more fun and fulfilling now because teens are involved in the planning.

Mold Their Own Character

Finally, teens have a strong and noble desire to figure out who they really are and to begin to mold their future. Through prayer Jesus Christ continued to mold his character to the will of God until the night before he died. In the Garden of Gethsemane, he prayed until his will became the same as his Father's (Matthew 26:36-46). Then He suffered pain and death, for us. Our hearts and characters can only change through prayer and

submission to God's will. Anything else is sin and will destroy the person God wants us to be.

Although the acts of our fleshly nature (Galatians 5:19–21) give us momentary thrills and satisfaction, they offer no lasting joy or peace and usually have consequences that we hate. Ways of having fun that go against God's word leave us with a sense of regret and guilt instead of joy and peace. It is ironic that the things many teenagers do to find fun are the very things that rob them of freedom in the long run.

"The fruit of the Spirit is love, joy, peace, patience, kindness, goodness, faithfulness, gentleness, and self-control. Against such things, there is no law" (Galatians 5:22–23). There are many activities we can do for fun that will in no way compromise God's will for our lives. While these things may not provide us with the immediate thrill that wilder and daring activities do, the submission to God's word will always give us a deep and lasting joy, a sense of freedom that leaves no regret.

"It is for freedom that Christ has set us free" (Galatians 5:1). As teenagers struggle and search for freedom, it is my prayer that they will *"look intently into the perfect law that gives freedom"* (James 1:25). According to God's word, it is not only possible for teens to be spiritual and have fun, but also necessary for teens to be spiritual to have real fun.

Can I leave you three challenges?

1. To teens who are not Christians: please use your energy to give God a chance by studying his word.

2. To teens who are Christians: realize how lucky you are to have found Christ. He will guide you to eternity and has given you the church. Keep reading his word.

3. To parents and ministers of teens: Point them toward God, His word, and His kingdom. Also help them pursue their search for fun and freedom and peace.

God bless you—everyone.

SECTION FOUR

On to Maturity

Growth With and Without Anxiety

by Ellen Faller

> *"Let your forbearing spirit be known to all men. The Lord is near. Be anxious for nothing, but in everything, by prayer and supplication with thanksgiving, let your requests be made known to God. And the peace of God, which transcends all comprehension, shall guard your hearts and minds in Christ Jesus."* (Philippians 4:5–7)

In the passage above, God commands us not to be anxious about anything. Rather, we are to submit all our requests to him by prayer and petition, trusting that he will take care of us. But is that humanly possible? The answer is yes because God never commands us to do the impossible.

As one who has struggled much and continues to struggle with anxiety, I can see that the issue is myself. When I trust God and rely on his strength, daily, I can overcome anxiety. When I rely on my own strength and abilities, anxiety overcomes me. To help us develop the ability to overcome anxiety, let us explore four areas of anxiety as it relates to our spiritual growth.

1. The paradox of anxiety and growth.
2. The patterns of anxiety in our lives.
3. Anxiety as the antithesis of faith.

4. Anxiety as an invitation to grow.

Let us begin by defining the topic of anxiety. Most of us are familiar with feelings of anxiety, though it may be difficult to explain them. Webster's dictionary describes anxiety as "a painful uneasiness of the mind with regards to impending or anticipated ill, circumstance or situation." So, anxiety is a state of mind, and internal alarm warning us of an upcoming inability to deal with a stress producing unknown.

The Bible never defines anxiety: it equates it with worry. The scriptures, however, have much to say about the opposite of being anxious-peace, joy, faith, contentment, confidence and composure and self-control. If you struggle from time to time with maintaining those qualities, then doubtless you are a victim of anxiety, just like me.

The two most common causes of anxiety are fear and laziness. Fear is so widespread that we can easily misinterpreted it for anxiety. It is prevalent in our relationships with other people-timidity, conflict avoidance, fear of rejection or persecution, fear of being tied down, fear of one's true self being known, fear of challenge, etc. Also, in our relationship with God-insecurity, lack of confidence, feeling of inadequacy, discontentment, and fear of non-performance, etc.

Laziness produces anxiety by causing a conflict to arise between what we know we should do and what we are doing. How many of us have arrived at an appointment anxious, out of breath and late because we were lazy and kept hitting the snooze button? Laziness can also stop us from dealing with sin or reaching out to the lost, setting us up for the anxiety of guilt and the frustration of unfulfilled purpose.

External pressures and circumstances beyond our control are other sources of anxiety. How do you react when a family member dies, your car breaks down on the way to work or you have to decide between two equally appealing alternatives

(Which dress should I buy? Which meal should I order?)? Clearly there are many stress-producing factors surrounding us in everyday life, and we cannot escape the temptation to be anxious. As Christians, however, we can learn to cope with stress in a positive and productive way without anxiety. Asking advice of one we trust to give us God's solution is one easy solution.

The Paradox of Anxiety and Growth

In the extreme case, feeling of anxiety may paralyze us from acting rationally. When acted upon and not reacted upon, however, they can be tremendous stimulators of growth. Here we have the paradox of anxiety and growth. If we choose to walk by sight and not by faith, anxiety may completely inhibit our spiritual growth. If we choose to walk by faith and not by sight (2Corinthians 5:7), anxiety can motivate and compel us to grow.

Spiritual growth is measured by developing maturity, becoming more like Christ (Ephesians 4:16). Because each anxiety producing situation gives us an opportunity to walk by faith as Jesus did, anxiety can promote faith and growth. Feelings of anxiety serve us spiritually in the same way that disease symptoms serve us physically. They are warning signs indicating that action is needed. If a person acts after recognizing symptoms of an illness, like getting rest when you catch a cold, there is likely to be no chance of pneumonia. Likewise, when a Christian recognizes increased anxiety, she acts on faith and prayer and grow. God loves each person uniquely; He knows what we need to grow in our faith in Him. He allows to happen whatever challenge we experience to help us grow. "All things work together for good."

"In Me you May Have Peace"

Let us examine the example of Jesus as it relates to anxiety. 1 Peter 2:21 tells us that *"Christ suffered for us, leaving an example for us to follow."* What kind of example would you have been if you had the kind of stressful days Jesus had in Mark 1, 6

and Luke 8? Christ must have been tempted to be anxious many times as he was constantly hemmed in by the pressing demands of the multitude. Persecution, insult, and rejection followed him everywhere. He had the most monumental task in history to complete with only three short years to do it. He had to suffer and die for crimes he never committed. Yet Jesus never lost his composure as He shared the truth of God with the multitudes. He was able to tell you and me, *"In me you may have peace. In this world, you will have trouble, but take heart. I have overcome the world"* (John16:33).

If we follow Christ's example, we will be able to find the same freedom from anxiety that he did. His promise in Matthew 11:28-30 still holds true for us today: *"Come to me all you who are weary and heavy-laden, and I will give you rest. Take my yoke upon you and learn from me, for I am gentle and humble in here, and you shall find rest for your souls. For my yoke is easy and my load is light."*

Jesus understood anxiety, better than any of us. Hebrews 2:17-18 records that *"He had to be made like us in every way that he might become a merciful and faithful high priest in things pertaining to God, to make propitiation for the sins of the people. For since he himself was tempted in that which he suffered, he can come to the aid of those who are tempted."*

Because of that fact, Jesus can show us how to overcome anxiety. Victory in this area is both a matter of trust and faith and a matter of action to be obedient to God. In Hebrews 5:7-9, the Bible states that Jesus offered up prayers and petitions to the one who could save him but that he learned obedience through suffering. I believe that the attitude of Christ in the garden of Gethsemane is the ultimate example for us of overcoming anxiety. The stress he experienced at that time was far greater than any of us can imagine but he did not give in to it. Instead, he prayed himself into submission to the will of God.

Note that both Hebrews 2:10 and 5:9 refer to Christ as

having been made perfect. But how could he have been made more perfect than he already was? The Greek word for perfect may also be translated as complete or mature. Christ showed his spiritual maturity by submitting himself to God's will even in the toughest situations and thereby exhibiting growth. When we follow his example in overcoming anxiety, we too will experience great growth.

Pat Gempel recently confided to me that she has struggled with anxiety all her life. I was amazed for I would never have known it by observing her actions and speech. Her life represents Christ to the world, no matter what internal battles she is having. She has decided to follow Christ's example of praying herself into submission to God's will in every circumstance. Thus, she acts on faith instead of reacting to anxiety. She is not perfect in overcoming anxiety, but she has given me the confidence to know that growth despite anxiety is indeed possible.

Patterns of Anxiety

Achieving any goal involves defining its beginning and end points, then developing a plan for progressing from one to the other. It is therefore important to understand the patterns of anxiety in our individual lives so that we can know from where we are starting and have a sober estimate of our spiritual condition (Romans 12:3).

Expressions of Anxiety

We express anxiety in two general ways: internally and externally. Internal manifestations are self-destructive. We withdraw to avoid anxiety producing situations, thinking we can escape from or compensate for anxiety without solving its underlying problems. The result is the creation of additional anxiety.

For example, you may become depressed and frustrated at your inability to lose weight. You forget about it for a day and Binge. The next morning you must face anxiety plus two

additional pounds. Perhaps you deal with anxiety by indulging in some sort of sexual gratification, such as masturbation. Or by watching TV all night, or chewing your fingernails down to the quick, or oversleeping. Since such behaviors are not productive, godly, or acceptable to Christ, they are not appropriate ways for a Christian to deal with anxiety. Neither do they work. Instead, they pull us into vicious cycles which are difficult to break.

The inability to cope with anxiety internally often leads us to express it externally in anger, fits of rage, impatience and blame shifting. In Matthew 16:22, Peter became anxious and unable to cope with the knowledge that Jesus was going to the cross and that, as Jesus' disciple, he must follow. He vented his anxiety in anger against Jesus.

Anxiety led Adam to try to shift responsibility for his sin onto Eve in Genesis 3:12. In the same way, Eve tried to blame the serpent for her sin (verse 13). The two were afraid of God after their deliberate disobedience and therefore anxious about its future consequences. Blame shifting also occurs in a subtle way in some forms of mental illness or when a person gives up on himself. We relinquish responsibility for our own actions and claim, "It's society's fault, not mine.

Anxiety in Our Relationship with God

Do you feel unfulfilled in your relationship with God? Are you insecure, afraid, or distant in that relationship? Do pangs of guilt grab you when you pray? If your answer is yes to any of those questions, you are likely experiencing anxiety in your relationship with God.

When we sin or are inconsistent with God, anxiety results. Laziness, emotionalism or too many activities may be crowding quality time with God out of your life. You begin to feel anxious and guilty about your lack of commitment. You grow distant from God because you can't know someone with whom you don't spend time. Discontent and the feeling of unfulfillment start creeping in because you think God is not meeting your needs,

when, you are not letting him. The pattern of anxiety paralyzes you so that you feel increasingly unworthy to come before him in prayer. You start to doubt God's ability to love you as you are and think that he could never use someone like you. You stop sharing your faith because you've lost everything you once had to give.

Undealt with sin can bring on that pattern of anxiety. Psalm 38 records David experiencing it after his sin with Bathsheba. David's restoration of his relationship with God in Psalm 51 proves it doesn't have to be that way.

Anxiety in Our Relationships with Others

Anxiety in our human relationship is nearly as devastating as anxiety in our relationship with God. That is because we are afraid to be known or hurt. For example, when I was expected to complete this chapter of this book in a given amount of time, I found myself being deceptive about whether it was completed and avoiding the person to whom it was to be given. I was afraid to reveal my true self, fearing I would disappoint people and lose credit in their eyes.

However, I found that the less upfront I was with people, the worse I did spiritually. My fears turned out to be unfounded. I was accepted and loved for who I am, not for what I could produce. If I had been honest from the beginning about what I was really feeling and thinking, it would have been easier for me. Increased anxiety made it double difficult for me to write. Check your own life. Do you ever find yourself playing a role because you desire approval and acceptance? Anxiety in our relationships comes from worrying too much about what others think of us instead of seeking approval from God (1 Thessalonians 2:4).

Wanting all our relationships to progress smoothly without any conflict or struggle also set us up for an anxiety attack. When expectation and perceptions differ between two people, conflicts are bound to arise. For example, I served in the ministry with a highly talented sister who was living a mediocre Christian life. When she didn't fulfill my expectations, I became frustrated and

angry. Instead of helping her through the changes she needed to make, I grew increasingly independent of her.

The productive way of dealing with anxiety in a relationship is to take responsibility for the changes that need to be made. Paul, like Christ, had a deep concern for people, but it led him to take positive action, not negative reaction.

Anxiety in Our Responsibilities

Any undealt with responsibility or unfulfilled obligation creates pressure and can lead to anxiety. This is true from the smallest task, like unmade beds or unwashed laundry, to the largest, like not completing and important project on time. The source of the anxiety is a lack of discipline and/or organization.

Punctuality is a responsibility we all have as Christians, one that can produce anxiety if we don't plan well. One day last week I didn't leave early enough for a meeting at work and found myself stuck in the worst traffic jam I'd seen in a long time. It soon became apparent I would be late. I had a hard time fighting the anxiety I felt. My mind went through a range of emotions-impatience, frustration, anger, fear, guilt-before I realized that this was an external pressure I couldn't change. I resolved to make the best of it and leave earlier next time.

If we immediately correct a problem in discipline, we will avoid much anxiety. If we leave it unchecked, sloppiness, lateness or irresponsibility will steal our joy of being a disciple. "Act NOW" is my motto. When you see something that needs to be done, do it. When you receive a long-term project, start it immediately, set goals to pace yourself and plan to finish it early.

Anxiety: The Antithesis of Faith

Why God Allows Anxiety

It may be difficult for you to understand why a loving, providential God allows you to be anxious. God certainly has the

power to make us completely peaceful but that would be contrary to the way he works in our lives. The Lord uses anxiety as an acid test of our faith and as an opportunity for us to grow spiritually. Anxiety forces us to decide who we will rely on, ourselves or God.

In 2 Corinthians 1:9, Paul relates that the pressure he was under in the province of Asia was *"far beyond his ability to endure."* However, he understood that God allowed it to happen so that he *"might not rely on himself but on God who raises the dead."*

I doubt we can relate to the sufferings Paul endured (2 Corinthians 6:4–10). Yet he remained confident and calm, realizing that "we have this treasure in earthen vessels, that the surpassing greatness of the power may be of God and not from ourselves. We are afflicted in every way, but not crushed; perplexed, but not despairing; persecuted, but not forsaken; struck down but not destroyed' always carrying about in the body the body of the dying Jesus, that the life of Jesus also may be manifested in our body. For we who live are constantly being delivered over to death for Jesus' sake, that the life of Jesus also may be manifested in our mortal flesh. So, death works in us but life in you. But having the same spirit of faith, according to what is written, *'I believed, therefore I spoke'*, *we also believe; therefore, we also speak"* (2Corinthians 4:7–13). Paul understood that faith was God's answer to anxiety.

Learning to Pray

We do have a choice: either to overcome anxiety or be overcome by it. Victory begins with learning to pray as never before, then acting upon those prayers with trust and obedience to God. Consider these verses:

- Proverbs 3:5–6: *"Trust in the Lord with all your heart and do not lean on your own understanding. In all your ways acknowledge him, and he will make your paths straight."*

- Philippians 4:6: *"Be anxious for nothing, but in every-thing, by prayer and supplication with thanksgiving, let your requests be made known to God."*

- James 1:5–8: *"But if any of you lacks wisdom, let him ask God, who gives to all men generously and without reproach, and it will be given to him. But let him ask in faith without any doubting, for the one who doubts is like the surf of the sea driven and tossed by the wind. For let not that man expect that he will receive any-thing from the Lord, being a double-minded man, un-stable in all his ways."*

Prayer takes faith (Mark 11:24, Luke 18:1–8) and humility before God (1 Peter 5:6–7). It takes time to learn but is the key to overcoming anxiety.

Anxiety: An Invitation to Grow

Five practical ways we can learn to trust God to overcome our anxiety and grow in faith:

1. **Develop your relationship with God.** Take time to pray, study and meditate daily. Keep a godly, prayerful focus throughout the day, striving to walk with Jesus wherever you go. Cultivate godly confidence resulting from knowing your competence comes for the Lord, not yourself, 2 Corinthians3:4–5. Realize that God can use you to the extent of your faith and that you have no reason to feel inadequate. Study the examples of Moses, Gideon, Isaiah, and Jeremiah if you doubt that is true. Learn to identify your anxieties and let God handle them through your prayers (Philippians 4:5–7). Jesus was at peace with his decision because he spent much time in prayer. Luke 6:12 records that he spent an entire night praying about the choice of his twelve apostles. Prayer allows us to make calm confident decisions.

Anxiety will either cause us to draw closer to God or turn away from Him in bitterness, disappointment, and despair.

2. **Learning to take things one day at a time like Christ did will facilitate our peace of mind.** Jesus didn't see the crowd as "all these people to deal with" or places to go as "too many appointments to keep". He dealt with people as individuals and with appointments as they came. When crowds were pressing him in Luke 8, he took time to give a bleeding woman the personal attention needed. We need to prioritize the demands of our day and meet each need before going to the next. When I take things one at a time, it is easy to give my best to each person and trust God will work through me to accomplish his purpose. We need to consciously take time to rest, exercise, be alone, do household chores and have fun with others. Jesus showed us what a busy but balanced schedule looks like in Mark 6. He called his disciples to *"come away with me to a quiet place and get some rest,"* but he was compassionate and flexible enough to feed the 5,000 when the need arose. From my own life, I can see how important it is to get exercise. Exercise is a method of stress reduction. Even the Bible says that *"physical training is of some value"* 1 Timothy 4:8.

3. **Deal decisively with sin.** Jesus was able to be perfectly at peace because he was perfectly obedient to God. John 8:29 says *"I always do what pleases him."* 2 Corinthians 7:1 teaches to strive for perfection out of reverence for God. The man struggling with sin in Romans 7 must have been miserable. Far too often I hear myself and others say: "for the good that I wish, I do not do, but I practice the very evil that I do not wish" verse 19.

James 5:16 tells us we must admit our sin to God and other Christians to overcome them and be healed.

4. **Learn to be content.** Women are especially prone to lack of contentment. We should take Paul's admonition in Philippians 4:11–13 to learn to be content whatever the situation. We should concentrate on the positive (Philippians 4:8–9), rejoice in our trials (Romans 5:3, James 1:2–3) and be thankful in everything (1 Thessalonians 5:16–18). As a young Christian, I was discontent about not having a husband. I went through several relationships, hoping each man would be "the one." Ironically, it wasn't until I became content with being single, that God blessed me with a long-lasting relationship. We can trust God. He knows what we need. Some may never marry. Some may never have much money. Others will be ill. That doesn't mean the Lord has forsaken us. He works all things together for the good of those who love him (Romans 8:28).

5. **Develop strong relationships in the church.** Be real and share your life with others. You will become like the people you spend time with (Luke 9:39–40). Choose some strong people to be your close friends. Stick with them as you give to others. Be willing to challenge and accept challenges without losing the love and loyalty of a friendship.

The question remains: is growth without anxiety possible? I would like to think so, but the truth is, I have yet to find a person who doesn't have to deal with anxiety from time to time. One thing is certain growth with anxiety is a reality. Our spiritual growth depends on how much we are willing to pray and act on faith despite our anxious feelings.

13

Developing Your Prayer Life

by Chris Fuqua

My earliest recollections of prayer are as a young child with my grandparents. We always prayed together at bedtime, a moment I grew to look forward to. That memory has stayed with me because it was a beginning, my first attempt to communicate with God.

Many years passed before I seriously attempted to re-establish that communication. I have been a Christian now for seven years, and it is exciting to see how far my relationship with God has come. I can remember stumbling through a short prayer as a young Christian and feeling embarrassed at my inability to express my heart the way others could. Since that time, I have struggled to become closer to the Lord through prayer and have found that developing a constantly growing prayer life is the greatest on-going challenge of my Christian life. It has been hard but very rewarding work as I've seen that one's prayer life can keep growing through the years. I hope this article will lead you also to grow in your prayer life as I share some of the lessons God has taught me thus far.

Effectiveness in our prayer lives hinges upon the attitudes in our hearts toward God. I used to think that the only key to having a great prayer life was consistency. Praying every day without exception is very important, but as I worked diligently toward that goal, I found another element was missing in my relationship with God.

Jesus said that the greatest commandment is to *"love the Lord you God with all you heart and with all your soul and with all your strength and with all your mind"* (Luke 10:27). My problem was that my mind was engaged in the activity of prayer, but my heart was not. Have you ever found yourself falling into that habit? While your lips are praising God, your thoughts are on what you need at the grocery store or your schedule for the day.

I have become convinced that the quality of our prayer lives is directly dependent on how much we truly love God. Many of us have the outward signs of being committed to God: we are evangelistic, faithful churchgoers, servants to the saved and the lost. But we must also be concerned with the inward signs of commitment. One of the most important signs is having our hearts and minds set on drawing near to God through prayer. We must strive to really communicate with him. Too many of us have fallen into the routine of Christian life without being tuned into the Savior who died for us.

From examining the lives of Christ and other Biblical characters, I have found four keys to developing our prayer life:
- Wholeheartedness
- Obedience
- Humility and
- Faith

Wholeheartedness

A dictionary definition of wholeheartedness is "completely and sincerely devoted, determined or enthusiastic". David personifies this attitude in Psalm 42:1–2: *"As a deer pants for streams of*

water, so my soul pants for you, O God. My soul thirsts for God, for the living God. When can I go and meet with God?" David obviously loved the Lord wholeheartedly because he longed to talk with God whenever he could. He made time to pray.

Mark 1:35–36 record the example of Jesus making time to be alone with God: *"Very early in the morning, while it was still dark, Jesus got up, left the house, and went off to a solitary place where he prayed. Simon and his companions went to look for him and when they found him, they exclaimed: Everyone is looking for you."* Jesus had more demands on his time than we do. He wanted special time alone with God when His day began. Why? He loved the Father with all his heart, mind, soul, and strength. He knew God had power and strength.

The challenge for us is clear-to have a wholehearted love for God. We must examine what our actions prove: do you love God more than an extra hour of sleep? More than a TV show or leisure activity? More than your own self? If we love God with every part of our being, then we too will ask "When can I meet with my God"?

Obedience

In human relationships, we know that actions speak louder than words. It would be difficult for me to believe someone who said he loves me if he constantly ignored me or treated me with animosity. In the same way, our obedience or lack of obedience to the commands of God sends him a direct message of how we really feel about him.

I John 5:3 teaches that love for God is *"to obey his commands."* Loving God with all our heart means obeying him with all our heart. *"The prayers of a righteous man are powerful and effective"* (James 5:16), because the righteous man loves God enough to want nothing to hinder his communication with the Lord. He remembers that, even for the Christian, sin separates people from God and dulls his ears to their prayers (Isaiah 59:1–2).

Consider the story of King Saul who was a powerful leader for the Lord, rescuing the people of Israel from defeat (1 Samuel 11). Four chapters later, however, we find the beginning of his spiritual death as he starts to follow his own way instead of the way of the Lord. 1 Samuel 15:3 records Saul's mission from God: "Now go, attack the Amalekites and totally destroy everything that belongs to them". I Samuel 15:9 describes his direct disobedience to God's command: *"But Saul and the army spared Agag (the king) and the best of the sheep and cattle, the fat calves and lambs-everything that was good. These they were unwilling to destroy completely, but everything that was despised and weak, they destroyed."*

Imagine how hurt and angry the Lord must have been when Saul, confronted by Samuel about his sin, said in 1 Samuel 15:20: *"But I did obey the Lord!"* As a result of that incident, God took the kingship from Saul and gave it to David, a man after God's own heart. Saul lost his crown and more. I Samuel 16:14 says that *"the Spirit of the Lord had departed from Saul."* All because he felt he could improve on the plans and commands of God. Have you ever studied the Bible with someone that thinks their traditions are more important than the direction of God? Some individuals even ignore the fundamental direction of God on how our sins are forgiven and we can receive God's gift of His Holy Spirit (Acts 2:38 ff).

Perhaps you can recall times when you, like Saul, thought you had a better way, and that God wouldn't care if you changed what he said just a little bit. Samuel summed up the Lord's feelings on this matter in 1 Samuel 15:22—*"does the Lord delight in burnt offerings and sacrifices as much as in obeying the voice of the Lord? To obey is better than sacrifice, and to heed is better than the fat of rams. For rebellion is like the sin of divination, and arrogance like the evil of idolatry."*

We are usually on our guards against the "big sins"—sexual immorality, drunkenness, lying, hatred, etc.—and we need to be.

A Christian never becomes so spiritual that he is above falling into blatant sin, as David did with Bathsheba. But we must also be on the lookout for "the little foxes". We read about them in Song of Solomon 2:15—*"Catch for us the foxes, the little foxes that are in bloom."* The lack of adding to our faith, knowledge, lack of discipline (self-control) and growing closer to God is also sin. Growing to be more and more like Christ is more difficult than conquering and eliminating the sin list. It takes a lifetime of growth. Without time with God, we can't do it.

Our prayers to God must be primarily to seek His wisdom, love, and power to lead us through our struggles. He knows what challenges us. Jesus said, *"not my will but your will be done."* We shouldn't be telling Him what we want Him to do for us. He will lead us, to be more like Christ in every way. To Him be the glory for His love, power, and guidance. He knows what we need, and He loves us more than we love the most important person in our life. He will guide us for eternity.

Humility

"The Lord is close to the brokenhearted and saves those who are crushed in spirit." (Psalm 34:18). Effective prayers do not come from prideful hearts. One of the most touching passages is Psalm 51:17 in which David, who has sinned sexually with Bathsheba, expresses his contrition to God and to the prophet Nathan: *"The sacrifices of God are a broken spirit; a broken and contrite heart, O God, you will not despise."* In this psalm, David exhibits several qualities of godly sorrow that are worthy of our imitation in prayer.

He took:

- Full responsibility
- Desired to Repent (change his ways)
- Prayed for God's help

Full Responsibility

He asked God in Psalm 51:2–3 to *"wash away all my iniquity and cleanse me from my sin. For I know my transgressions, and my sin is always before me."* David never made any mention of Bathsheba in his prayer, although she was just as responsible for the sin as he was. He also failed to mention all the pressure that he was under as king of Israel. Those were two ready excuses he could have made, yet he showed his true humility before God by speaking only of himself and his sin. Do you take responsibility for the sins you commit?

I have had times in my life when I sinned either by omission or commission, and my first thought was of how I wouldn't have fallen if it hadn't been for this person or circumstance. We need to realize that our sin is our own and be willing to accept the blame for it ourselves. God teaches us to people who take responsibility for our actions.

Desire to Repent

David asks God in Psalm 51:10–12 to *"create in me a pure heart, O God, and renew a steadfast spirit within me.... restore to me the joy of your salvation and grant me a willing spirit to sustain me."* David knew that he needed God's forgiveness and power to change his inner character. It is significant that he asked for those things before requesting that he be different on the outside. He was more concerned about having a pure heart and good conscience before God than he was about his outward image to others.

Jesus' advice to the Pharisees on this subject is recorded in Matthew 23:25–26—*"Woe to you teacher of the law and Pharisees, you hypocrites! You clean the outside of the cup and dish, but inside they are full of greed and self-indulgence. Blind Pharisee! First clean the inside of the cup and dish, and then the outside will be clean."* We cannot afford to simply change the outward signs of our sin. We too must ask God to change us from the inside out.

Prayed for God's Help

In Psalm 51:13–15, he said, *"Then I will teach transgressors your ways and sinners will turn back to you, O lord, open my lips and my mouth will declare your praise."* David knew that having a humble and contrite heart along with the joy of his salvation would motivate him to teach others about God's love and forgiveness.

Let us examine ourselves considering David's example and answer this question: do I truly have a humble heart in my relationship with God or am I allowing pride to get in the way?

Faith

"Therefore, I tell you, whatever you ask for in prayer, believe that you have received it, and it will be yours" (Mark 11:24). What a tremendous promise from God and what a challenge to our prayer lives! Anyone who has an active and growing relationship with God will be tempted to have doubts about their prayers being answered. Perhaps you are working at overcoming a chronic sin or praying for someone who is at a crucial point in their conversion. Perhaps it is for a Christian who is struggling with her commitment. There you are on your knees having poured out your heart to God. Sound familiar?

Remember that God created all of us with free will. He sent his one and only son to give us an example of how to live this life on earth. He gives everyone a chance to choose to be with them for eternity. We know we must believe in God and Christ and decide to be obedient to their simple plan of salvation (Acts 2). We must decide to follow Christ, and have our sins forgiven through baptism and to receive the gift of His Holy Spirit. We must then obey His word for the rest of our life on this earth. That is a decision for everyone to make. Pray that God will help you understand how you or others can help the person you are praying for to do what God's word commands. Have faith that God will answer your prayer.

When we pray, we must remember James 1:6–7: *"But when he asks, he must believe and not doubt, because he who doubts is like a wave of the sea, blown and tossed by the wind. That man should not think that he will receive anything from the Lord, he is a double-minded man, unstable in all he does."*

That point is illustrated by a good friend of mine who prayed daily for a Christian husband. She had a few serious relationships with brothers which didn't progress to the point that she had a husband. She expected the Lord to answer immediately and according to her will, not his. When the problem was identified she prayed for the power to overcome her doubts, for patience and for His will to be done. His will won't always align with our desires.

Paul described the disciple Epaphras in Colossians 4:12–13 as someone who was *"always wrestling in prayer."* We need to follow his lead and wrestle our doubts to the ground but balance our wrestling with *"His will be done"* and *"help me overcome my disbelief"* (Luke 9:24).

Jesus taught his disciples two important concepts about faith:

- All things are Possible with God. In Matthew 19:26 Christ told the 12 apostles that *"with man this is impossible, but with God all things are possible."* Throughout the Scriptures, we read of miracles: the creation, the parting of the Red Sea, the feeding of the 5,000 and the physical resurrection of Christ. We accept those things by faith yet struggle to believe that God can work out much less difficult problems in our own lives. We question whether family members can become Christians instead of asking God to help us reach them. We ask, "How can you work through a person like me?" Instead of asking God, show me what I can do for you. Please lead me today. Ask yourself if you remember the power of God to do the impossible things in our lives and the lives of those we know.

- Be Persistent. Jesus told his disciples the parable of the persistent widow in Luke18:1–8. He showed them that they should always pray and not give up. The parable tells of a widow who goes to an unsympathetic judge and seeks justice against her adversary. Although he denies her request, she pesters him again and again until he gives in out of sheer fatigue.

Let us examine our hearts in the areas of wholeheartedness, obedience, humility, and faith, then determine how we are going to grow in each of these qualities. Becoming closer to our Father in heaven is the reward for the changes we make. Let us decide today to love him with all our hearts, minds, souls, and strength.

14

Developing Our Talents

by Marcia Lamb

Talents are God-given abilities that enable us to be more effective and productive people. Talents that are submitted to God's will and service can grow, develop and benefit the kingdom. Without godly confidence, however, our talents may lie dormant. Consider a moment-the parable of the talents (Matthew 25:14–30).

A pitiful little man walks apprehensively through the large, majestic corridor of his master's palace. He has been summoned to his master's chamber to give an account of the loan the master gave him years ago. The man couldn't even remember such a transaction. "Surely, there's been a mistake," he thought. "I don't remember ever receiving any talents. Why, if I had received a talent, I'm sure I would have kept it in a prominent place." Then a cold chill ran through his body as he recalled the damp, dark night that he buried the talent in his own backyard.

Now he is in the master's chambers, clenching the tarnished talent as he listens to other servants give account to the master. His thoughts reveal attitudes that were buried and tarnished as

well. "This is such a small talent compared to the others. It wasn't fair that I didn't get more. Oh, well, who wants more talents anyway. It would just have meant more work. I know the way things happen when my master makes investments. Things inevitably grow and multiply. Keeping up with the interest would have been too much for one measly talent. I'd never get to do what I want to do. Who wants all that responsibility? Besides, what would I get out of it anyway? If he doesn't like what I've done, it is his own fault. Who asked him for this talent anyway? He should have known better than to give it to me."

"Master, I knew that you are a hard man, harvesting where you have not sown and gathering where you have not scattered seed. So, I was afraid and went out and hid your talent in the ground. See, here is what belongs to you."

"You wicked, lazy servant...Take the talent from him and give it to the one who has the ten talents. For everyone who has will be given more, and he will have an abundance. Whoever does not have, even what he has will be taken from him. And throw that worthless servant outside, into the darkness, where there will be weeping and grinding of teeth."

How much we are like this pitiful man in Matthew 25 until we realize that our talents are gifts from God. What an honor it is to be used in his service and to his glory. No matter how large or small our talent, we have a responsibility to use what he has given us. Many of us have the desire to be used by God in a special way, to fulfill the individual purpose he has for each of our lives. Oftentimes, however, we fail to see and develop the talents and abilities God has given us to accomplish those purposes. Human treasure chests of divine gifts lie buried in the sands of neglect and fear, frustrating both God and ourselves.

Ephesians 2:10 teaches that *"we are God's workmanship, created in Christ Jesus to do good works, which God prepared in advance for us to do."*

We must realize that we are God's workmanship and that he

will hold us accountable for the way we use or don't use the gifts he has given us, just as the master did his servants in the parable of the talents (Matthew 25:14–30). Considering that fact, we will explore four areas of our "treasure hunt" for hidden talents: recognizing our talents, burying our talents, using our talents and enhancing our talents.

Recognizing Our Talents

Webster's dictionary defines a talent as "a natural ability or power," adding that the word connotes "it is or can be cultivated by the one possessing it." A talented person can learn a skill quickly and easily because God has given him an innate head start in that area. Initially discovering what our natural talents are, however, may be more difficult. Fortunately, there are some clues to help us in our search.

Certain talents will be obvious, and parents, teachers and others will recognize them for us. Kim Evans' parents (Bob and Pat Gempel) realized her talent as a pianist after a few months of her piano lessons. She quickly surpassed the skill of her brother Doug who had been pounding away at the keyboard for two years. To Doug's relief, he was allowed to drop his lessons and pursue basketball. Kim was made to continue, even though there were times she hated practicing. Today, Kim is thankful to have developed a usable talent that brings joy to herself and others. We too should remain open to the guidance of mature adults who have a wider perspective on life. They can see the long-range development of our talents.

Sometimes we discover our talents by trial and error. How many of us remember the sudden realization that we were not slated to be artists when someone in art class thought our copy of the "Mona Lisa" was a basset hound? Keep trying out your various interests. The process of elimination will reveal where your native abilities lie.

Other talents become apparent when one tries to meet a

need that arises. I know a young man in DeKalb, Illinois who had developed a skill for sign language. Mike Rawls is not deaf, but he learned sign language to communicate with deaf visitors at church. Now two deaf men are Christians and others are being studied with because of Mike learning a needed skill.

Another way we can recognize our talents is by honestly and humbly listening to compliments we receive. What do your friends perceive as your natural abilities? Observe yourself. What do you enjoy doing? What comes easily to you? What new activity haven't you tried?

The parable of the talents shows us that we all have at least one talent. Most of us have many. Decide right now to discover what yours are in order that your life may more fully glorify God.

Burying Our Talents

In the parable of the talents, the servant who buried his talents was rejected by God. Far too many of us have fallen into this trap-regarding our talent as too small, we have buried it in oblivion's backyard. There are several ways we do this. Proverbs 13:7 states that *"one man pretends to be rich, yet has nothing; another pretends to be poor, yet has great wealth."* A false humility can keep us from searching for our talents and using them to the fullest. That kind of attitude needs to be exposed for what it is—inverted pride. Pride will cause our talents to be utterly useless as it did for Jerusalem in Jeremiah 13:8–11. Do you think you can't learn more about your talent? When someone challenges you on how you're using your talent, do you get defensive because they don't understand the demands of your field? For example, a vocalist can learn how to sing her best from a Christian ho is tone deaf but knows what it means to sacrifice. In the same way, a fisherman learned how to get a great catch from an itinerant preacher (Luke 5:1–11).

If our pride causes us to boast about what we've accomplished, forgetting the fact that the Lord has accomplished it, then we

need to remember 1 Corinthians 4:7—*"Who makes you different from anyone else? What do you have that you did not receive? And if you did receive it, why do you boast as though you did not?"* People who drop big hints about their great talents, under the guise of assertiveness, are usually not called upon to serve. Why? Their pride prevents them from serving the best interests of others. They will seek honor for themselves and not God.

Our sacrifices to God must be holy and pleasing to him. A talent that is offered in an unholy manner is like the maimed and blind sacrifice God rejected in the Old Testament. Closely examine your attitude about your talents to see if it contains any unholy or inverted pride. Why have a great but useless talent?

Fear buries our talents even deeper. A certain amount of fear is good because it humbles us and reminds us to rely on God. Courage can blossom when a fear is faced and overcome. If we let fear reign, however, we will become paralyzed and unable to use our talents.

Fear is an obstacle that I've had to learn to overcome. At a retreat I attended a few years ago, the participants shared the strengths and weaknesses they saw in each other. My lack of boldness was pointed out by many. My first response was, "Oh well, what is new?" Then I felt the horror of what I had just thought, and I made a firm decision: If a lack of boldness was the weakness most people remembered me for, then it needed to change.

Improving my boldness became my emphasis. I prayed about it, studied, and sought advice. Little victories were won along the way. Then I was challenged like never before—I was asked to sing a lead part at the Midwest Evangelism Seminar. I knew that about 2,000 people would be there. The song was "Amazing Grace." I knew the song needed to be sung with boldness and confidence. I spent hours praying and reading the words of the song imagining how Jesus would have sung Amazing Grace. He had seen me "through many dangers, toils and snares" and I was

confident that "his grace would lead me home." I wanted the audience to do the same.

The night of the concert I prayed for confidence, boldness and that the song's message would be clear. The song received a standing ovation. Since then, I've learned to be bold in other areas of my ministry as well. I have been able to study the Bible with a senator's wife, a registered nurse, and some social workers. All have become Christians. Submitting my talents and fears to God resulted in confidence flowing into my whole life.

We must overcome the fears that control us if we are to use any of our talents, especially those of teaching. When the fear of humiliation or rejection threatens to hold you back, remember the parable of the talents. The servant who complained about being afraid was explicitly told that was an excuse for being wicked and lazy.

Are you afraid your talents aren't good enough? What you really mean is that you are too lazy and selfish to pray and work at improving them so God can use you. Do you leave projects half finished? Are you willing to push through the awkwardness of trying something new? Does discipline seem like a creativity killer to you If your answer to any of those questions is yes, then your problem isn't lack of talent; it's laziness.

Using Our Talents

As we begin to recognize our talents (and realize what we need to change to be more like Christ) we begin to wonder how we can use them in God's kingdom, the church. Often, we hear talents discussed as they are used in a worldly context. Romans 12:1–3 is an excellent guide on this subject: *"Therefore, I urge you, brothers, in view of God's mercy, to offer your bodies as living sacrifices, holy and pleasing to God—which is your spiritual worship. Do not conform any longer to the pattern of this world but be transformed by the renewing of your mind. Then you will be able to test and approve what God's will is—his*

good, pleasing, and perfect will. For by the grace given me I say to every one of you: Do not think of yourself more highly than you ought, but rather think of yourself with sober judgment, in accordance with the measure of faith God has given you."

We see here the proper attitude we need toward our talents and God's will. It is in view of God's mercy that we offer ourselves. We do not deserve his mercy, but he has freely given it to us. We freely offer ourselves in return.

The sacrifice we give God is living, vital and diligent in every aspect of our being. We release all claim or right to our talents, no longer governing our actions by what's best for our talent but by what is best for the kingdom. Until we give our talents over to God's ownership, they will never grow.

I remember how much I wanted to join the Chapel Singers when they were first organized. Music majors had told me that I had a good voice and would help the group. I also sought advice from church leaders. Their opinions were unanimous- I was needed more leading Bible studies, discipling sisters, and managing my home.

At first, I was disappointed. Then I was reminded that God would give me singing opportunities if that was a talent, he wanted me to use. I accepted that advice and submitted to God and have been grateful ever since that I did. The Lord has allowed me to sing at some very special weddings and banquets plus he gave me the great honor of doing a solo with the Chapel Singers at the seminar. I have found his promise in 1 Peter 5:6 to be true: *"Humble yourselves, therefore, under God's mighty hand, that he may lift you up in due time."*

Effectively using our talents for God also takes a renewed mind (Romans 12:2). The patterns of this world tell us to use our talents to gain honor for ourselves. John 7:17–18 says we won't know God's will that way nor will we be a person of truth. The world says do your best for the best pay. God says you can't serve both him and money (Matthew 6:24). The world says use your

talents for self-fulfillment. God says, *"each one should use what-ever gift he has received to serve others, faithfully administering God's grace in its various forms"* (1 Peter 4:10).

The world will tell you that God can't use rock band musicians, but God has changed the lives of John Mannel and Bill Bennett. John became an elder and the director of the Chapel Singers. Bill used his experience to reach another rock singer who is now teaching a young adult Bible class. He also uses his talent in the homes of Christians as an outreach tool.

Objectivity about our talents is needed. Romans 12:3 warns us to have a sober judgment about our abilities, especially as they affect the church. If we have the talent to fulfill a need, we should soberly accept the responsibility. If we don't, we need to honestly admit we don't. However, sometimes God uses others to point out talents that we don't recognize to be talents.

Romans 12 says: *"In accordance with the measure of faith God has given you."* That means that our abilities can grow and develop as our faith grows and develops. God is in the business of turning our weaknesses into strengths (2 Corinthians 12:9–10). We have all seen people with little natural talent as a teacher or leader surpass those with a lot of natural ability. Their faith makes a difference.

Enhancing Our Talents

Romans 12:6–8 describes some of the different gifts that are present in the body of Christ. Though the text uses the term "gifts," the word is not considered to be referring to the miraculous gifts of the Holy Spirit. Rather these are responsibilities we all have: teaching (Colossians 1:28), contributing to the needs of others (2 Corinthians 9:7), serving (John 13:14–15), encouraging (Hebrews 3:13), leading (Matthew 28:18–20), and showing mercy (Matthew 5:7).

Our natural talents can enhance these spiritual "talents" that God has given us and vice versa. For example, natural talents

that enhance the spiritual gift of teaching are orderly thinking, good speaking ability and high intellect. It is sad to see excellent schoolteachers withhold those talents in the Lord's church. The older married women set up weekly classes for new brides. One sister who excelled in cooking taught a cooking class. Another sister taught sewing, another bookkeeping, and the overall Biblical structure for the family (the book of Ephesians). Older, more experienced disciples should teach those who are just starting a family (the book of Titus).

We should share with others the gifts God has given. The ability to encourage can be seen in people who can create beautiful calligraphy notes and prints. Growing and arranging flowers is a gift of some. Acting is a gift. One new disciple said when attending a fellowship gathering, "I thought after I gave up going to bars that would be an end to fun for me. But I've enjoyed tonight more than anything I ever did in the world. It's good to know the Christians can have fun."

The gift of contributing to the needs of others is another important gift to develop and enhance with our talents. Needs that can be met may be physical, emotional, monetary, or spiritual. Every group of disciples have great cooks, who can share by giving prepared meals for groups or shut ins. Financial gifts help the Lord's work to advance. Praise God for our financial blessings. The widow who gave all she had to live on, was praised by our Lord. That heart enables us to reach the world in our generation. He will take care of us now and for eternity.

The unity of the body is lubricated and held together by the selfless attitudes of servants who follow Christ's example of washing the disciples' feet (including Judas who left to betray Him) in John 13:15. Every disciple has a talent to give to the Lord. I will always be grateful for those who have served me. One young sister who helped me clean my house taught me how to organize my home. She shared with me with a joyful and efficient attitude. I shared with her some spiritual guidance. God

gave us friendship and mutual benefits.

Jesus was our perfect leader. His example and his words, teach us about how a disciple should lead others. We have a lot to learn about godly leadership. Some are talented leaders, naturally. Wherever you are in using your leadership talent you can learn from our Lord. He was bold when speaking God's will. He embraced those that wanted to learn from God. He spoke the truth of God to those who rejected him as the son of God. He called out their sin of lack of obedience to the scripture and lack of faith. Jesus met physical, emotional, and spiritual needs perfectly. He set us an example in his relationship with God, his prayer life, his treatment of others and his reliance on God to obey His plan. We have Matthew, Mark, Luke and John and the rest of the New Testament—and the Old Testament (which predicts his coming) to learn from.

Some of us have innate leadership talent which includes organization, goal setting, discipline, follow through, and persevering when things are difficult. Observe children at play. One will keep toys in a perfect row, others will scatter them, their objective is to scatter all of them. Jesus was a talented leader. He was challenged to set us a standard; he gave his life for us.

Satan tests and tries leaders. Jesus was tested in many ways. Satan works directly, and through our fellow human beings. Consider how painful it was for all the apostles, including Peter, to deny our Lord in His most important trial. The more talented you are the more Satan will test you. However, when you persevere to win the prize and God's victory: you will have eternal life with Him in the presence of perfect love, joy, and peace. Ask yourself: what victories has God helped you to accomplish lately? How can you use your talents in God's service? How do you need to grow?

Finally, pray and ask others, who know you well, what your talents are and how you can use them for God. Develop them with God's direction. I pray that you will submit your talents

to God's service of helping others. God will bless you with His miracles as you look back on your life (Luke 6:38).

15

Developing Godly Confidence

by Kim Evans

When you sit down in a chair, do you fearfully lower yourself into it, doubting whether it will support your weight? Do you question whether the light in your kitchen will glow when you flip on the switch? Of course not. We expect the chair and the light to function properly and meet our expectations because over time and through we have become confident in the carpenter and the electrician. We have sat in hundreds of chairs and turned-on thousands of lights. Each time we perform these everyday acts, our confidence is reaffirmed, leaving us with complete trust in the acts themselves and in the outcome, they will produce-a place to sit and a light to turn on.

Have you ever noticed, however, that the greater the dependence a person has in a certain situation, the harder it becomes for him to develop confidence in that situation? You may sit in a chair without a second thought, but when you were about to take your first airplane trip, you probably pondered it for days before confidently committing yourself to it. The airplane trip had a higher risk involved. It required you to be more dependent

on the pilot than you were on the carpenter. To fall to the ground in a chair would only cause embarrassment and perhaps minor injuries. To crash in an airplane would cost you your life.

With God, the dependence factor becomes even more demanding; it is not only total but eternal. God requires you to put your faith solely in him and to trust him with your life. *"Without faith, it is impossible to please God because anyone who comes to him must believe that he exists and that he rewards those who earnestly seek him"* (Hebrews 11:6).

Confidence in God demands complete dependence upon him and on the perfect plan he has for your life. The degree of confidence you have in God should be equal to the degree of confidence you have when you sit in a chair or turn on a light. It cannot be an arrogant or self-righteous attitude. Jesus Christ had complete confidence in his relationship with God, yet he humbly considered others better than himself (Philippians 2:3-5). Self-righteousness or arrogance is an assurance in self while godly confidence is a humble respect for God coupled with an understanding of what can be done through his power in your life.

We will explore three fundamental areas in which we can have godly confidence:
- God's love for us,
- Our love for God, and
- Our salvation

Confidence in God's Love For Us

Times of crises, moments of grief or hardship and unexpected turns of events are some of the situations that test our confidence and reveal where we are before God. This past year my confidence was put to the test. Nearly five months into my first pregnancy, I lost twins. I had to consider what my confidence was in and why.

The first area of confidence I had to deal with was God's love for me. I wondered why God would let such a painful thing happen to me if he loved me so much. But then I remembered

the following scriptures: *"And we know that in all things God works for the good of those who love him, who have been called according to his purpose."* (Romans 8:28), and *"What then shall we say in response to this? If God is for us, who can be against us? He who did not spare his own Son, but gave him up for us all—how will he not also, along with him, graciously give us all things?"* Romans 8:31–32).

Those passages assure me that God will work all things out for my good if I continue to love and trust him. Even when I don't understand the exact reasoning behind His decisions. I can be confident that in every situation his will is perfectly manifested (Romans 12:2).

God truly loves us and wants only the best for us. Remember that we are his children, bought at a very high price. He sent his only Son to die for us at a time when we were both undeserving and unappreciative. *"God demonstrates his own love for us in this: while we were still sinners, Christ died for all of us"* (Romans 5:8). I have asked myself if I would have been willing to sacrifice my twins for an ungrateful group of people. God's love for us went far beyond the pondering of a question like that; it bore itself perfect in action. We can be confident of God's love for us because it was demonstrated through the greatest sacrifice ever made, the gift of his beloved Son. Now *"love is made complete among us so that we will have confidence on the day of judgment, because in this world we are like him"* (1 John 4:17).

Confidence in Our Love For God

The next area of confidence I grappled with through the loss of my babies was my love for God. Matthew 22:37 states that you must love God with *"all you heart and with all your strength and will all your mind."* Before my pregnancy, it was difficult for me to understand how one could love the unseen. But loving God is like loving an unborn child. Any mother knows how easily that comes.

Loving God with all our mind requires study and meditation

on his word. We must *"find out what pleases the Lord"* (Ephesians 5:10) and apply it to our lives—for the rest of lives.

Loving God with all our strength is love in action, and a growing love. We are compelled to do that for *"Christ's love compels us to live a life worthy of the gospel of Christ"* (Philippians 1:27) and to *"shine like starts in the universe as we hold out the word of life"* to others (Phillippians2:15). Our love for God must dwell richly in our hearts, be ever on our minds and evident in all our actions.

Confidence in Our Salvation

The result of having confidence in God's love for us and in our love for God is confidence in our relationship with God. As Christians, we have the freedom to speak to God and about God to others. We can *"approach the throne of grace with confidence,"* *"receive mercy and find grace to help us in our time of need,"* Hebrews 4:16.

We can also have the surety of salvation (being with God, Christ, and the Holy Spirit in the presence of perfect love, joy and peace for **Eternity**) and look forward to the day of judgment without fear. Death is when our immortal life with God will begin, the time when we will be brought to perfection in Christ. We should eagerly anticipate death, not in a morbid sense, but in a way that exemplifies our desire to be wholly with our Father. "Therefore, we are always confident and know that if we are at home in the body, we are away from the Lord. We live by faith, not sight. We are confident, I say, and would prefer to be away from the body and at home with the Lord" 2 Corinthians 5:6-8. Saying this another way, I am confident that our twins are already with the Lord for eternity. Their hearts were beating when they went to be with my Lord.

Developing Confidence

We now know what confidence is and what we must be confident it, so how do we develop confidence? God's Word

gives us on important prerequisite-righteousness. Isaiah 32:17 teaches that *"the fruit of righteousness will be peace; the effect of righteousness will be quietness and confidence forever."*

Confidence is developed through an understanding that God's way is the best way to live. We must have the attitude of being willing to do whatever God commands, to *"seek the Lord, all you humble of the land, you who do what he commands. Seek righteousness, seek humility; perhaps you will be sheltered on the day of the Lord's anger"* (Zephaniah 2:3).

When we live out of step with God's plan, we experience chaos for ourselves and others. When we do what God commands, however, the result is a righteous life. When our life is righteous, we can be a *"living sacrifice, holy and pleasing to God"* (Romans 12:1), confident in him and in our relationship with him. Godly confidence comes from being one in mind and thought with God.

Obstacles to Confidence

There are two major obstacles to living a righteous life and developing godly confidence. The first is undealt-with sin. Since sin is the only thing that can separate us from Go, it will quickly rob us of our confidence if we don't deal with it. Sometimes we don't see our sin and need help to overcome it. God gave us other believers, the church to help us.

Christ died for our sins so that we would no longer have to live in sin but could live for righteousness. *"He himself bore our sins in his body on the tree, so that we might die to sins and live for righteousness; by his wounds we have been healed"* (1 Peter 2:24). Confidence is the natural result of crucifying sin and being righteous with a strong relationship to God. To develop confidence in ourselves and others, we must be able to recognize sin in ourselves (and others) and repent of our behavior and help others do the same.

Relying on self rather than on God is the second obstacle

to becoming a confident person. When we rely on ourselves, we are denying Christ as the Lord of our life. To see how those obstacles can affect our confidence, let's investigate the life and heart of a fictitious woman I will call Sarah Windor. Sarah is 25-year-old with a B.S. in biology from Boston University. She is single and employed by RCA in Burlington, Massachusetts. Her life and love for God are respected by those around her, and she sets the pace for the single women in the congregation. The group Bible study Sarah leads is effective, and she maintains an organized, disciplined life. In every situation she is eager to get advice, quick to listen and slow to speak. Yet, despite all these great qualities, when Sarah was asked, "what is your greatest weakness?" Her answer was "lack of confidence."

There are only two possible reasons for Sarah's lack of confidence-undealt-with sin or reliance on self. Although both obstacles to righteousness are manifested in various forms, the result is the same—one is stripped of one's godly confidence.

Looking into Sarah's life, we see that she appears to be eager to listen and desires to do what is best. However, looking into Sarah's heart, we find that she is striving to please people rather than God. She is relying on her own talents rather than using her talents and relying on God to get His job done. Looking a little deeper into Sarah's heart, we see hidden resentment toward one of the sisters she lives with. This undealt with sin is causing her to condemn herself in her own heart. The resulting lack of confidence before God causes Sarah to fear that those around her will see her true colors (1 John 3:21).

Sarah lives on a merry-go-round trying to catch her heart up with the image she portrays. Sarah or anyone else trying to develop confidence must live a righteous life that is based on a love relationship with God, not legalism. We need to think for ourselves and live open lives with an attitude of "what more can I do?" Remember that all confidence is demonstrated by action but not all action demonstrates confidence.

Growing in Our Confidence

Once our initial confidence has been established, how can we keep our confidence growing? Jesus was able to motivate his disciples all the way from leaving their worldly positions to follow him to going into all the world and spreading the gospel. To do this Jesus used steppingstones to build up their confidence, such as calming the storm for his disciples.

Luke 8:22–25 reads,

> One day Jesus said to his disciples, "Let us go over to the other side of the lake." So they got into a boat and set out. As they sailed, he fell asleep. A squall came down on the lake, so that the boat was being swamped, and they were in great danger.
>
> The disciples went and woke him, saying, "Master, Master, we're going to drown!"
>
> He got up and rebuked the wind and the raging waters; the storm subsided, and all was calm.
>
> "Where is your faith?" he asked his disciples.

Christ continually put his disciples in situations where their faith was tested. The result was obedience to him and an increased confidence in him. To increase our confidence, we must force ourselves and others to rely on God more and more. Recently, I assigned the task of organizing a church dinner to a sister who had never done it before. The task required her to rely on God and others, and it was a steppingstone to maturing in confidence. She thanked me for helping her to develop more confidence by giving her more responsibility. After organizing a few more dinners, it will take a larger task to create the challenge she will need to continue maturing in confidence. Also, she can teach others what she has learned.

Developing confidence is a process that continues throughout our entire Christian life. We all desire to be confident people

chosen by God to make a lasting impact on the world. God has given us all the talents we need to accomplish the challenge of going and "making disciples of all nations". Through our confidence in God, we have the power to answer His upward call.

16

Time Management and the Christian Woman

by Betty Morehead

"There is a time for everything, and a season for every activity under heaven". (Ecclesiastes 3:1)

The above scripture is a promise of God, just like the promise of eternal life, but we usually find it more difficult to believe. Picture the typical household all trying to eat breakfast, make lunches and leave at the same time in the morning. Or consider the businesswoman working to complete a project that has been stalled by weather and labor disputes. In the fast pace of modern life, it is easy to resign oneself to the attitude of "There just aren't enough hours in my day." But God promises otherwise. What is the answer?

In considering the topic of time management, the Christian woman needs to ask herself two questions: What is my part in organizing my time, and what is God's part? Both aspects will be discussed as we consider the following four steps to managing our time in a godly manner: pleasing God, setting priorities, planning, and putting the plans into practice.

PLEASING GOD

God's Plan or My Plan?

The place to begin for the solution of any problem is one's relationship with God. Psalm 127:1 state that *"unless the Lord builds the house, its builders labor in vain."* We all want our time and efforts to be productive and ultimately meaningful, but the Bible teaches that God must agree with our plans for them to succeed. There is no shortcut to knowing what God expects of us, but the daily study of his word will provide us with a standard for all our decisions. God does not want his children to labor in vain. He has given us his word to make us wiser than our enemies, to fill us with insight and understanding and to keep us from making wrong decisions (Psalm 119).

Prayers for God's Guidance

A relationship with God also involves daily prayer, a practice that teaches us to depend on him for guidance and support. Specific prayer increases our faith because it gives us more opportunities to see the ways God intervenes in our lives. Begin every day by asking for the ways God intervenes in our lives. Begin every day by asking for the Lord's help in using your time wisely. Pray throughout the day whenever your time is challenged by conflicting demands, or you have an unexpected free hour. "If any of you lacks wisdom, he should ask God, who gives generously to all without finding fault, and it will be given to him". (James 1:5)

Recognizing and Balancing Need

Two other principles to remember in pleasing God with your time are:

1. **Are you task oriented, or people oriented?** Often, we get so caught up with the job that we lose sight of our goal to serve God. For example, a woman can fall

into the trap of being a Martha instead of a Mary (Luke 10:38-41), someone so concerned about making all the preparations for a dinner party perfect that she barely has time to talk to her guests. That is the trap I would fall into when guests came for a meal at our home. My intent was that all their needs would be met. I attended to each crucial detail, fluttering from table to kitchen and like the butterfly, never landing anywhere for very long. The food was superb, as were the preparations, but my interaction with my guests was superficial. When I realized that my guests could help and that I could even leave dishes to wash later, I learned to concentrate on my company and to communicate the warmth that Christ would.

2. **The completion of one God-given task should never mean the neglect of another; both are important.** Does your definition of important agree with God's?

Priorities

When we have decided to submit ourselves and our plans to God and have sought counsel in the Bible, in prayer and from other believers, then we are ready to set priorities. God has given the guidelines to do this in Matthew 6:33–34—*"But seek first his kingdom and his righteousness, and all these things will be given to you as well. Therefore, do not worry about tomorrow for tomorrow will worry about itself. Each day has enough trouble of its own."*

Jesus teaches us not to expend time and energy on what may go wrong but to focus on what it means today to pursue God's will and to do what is best for his kingdom in every situation. As Christians, most of our dilemmas are not between good and bad, but between good and best. Pray, as Paul did in Philippians 1:9–10, that the Lard will lead you to what is best. Usually, God's method of answering our priority-related questions is through

the advice of stronger and more disciplined Christians than ourselves, Proverbs 20:18.

An aid to setting the proper priorities is to make goals for yourself and then match your time use to those aspirations. Constantly ask yourself if the way you are spending your time right now is helping you to become a more effective women's counselor, a mother of children who love God, a spiritually as well as professionally successful career woman, or a better wife.

Planning

The third step to fruitful time management is to plan ahead. It takes time to save time, but the reward is a more productive day. Planning weekly and daily seems to work well for me. On Sunday when I'm worshipping with the Lord's body, I pray that God will show me any needs in that group that I can meet. By the time I sit down that evening to map out the week ahead, I am aware of what present needs are, and my first responsibility is to God's kingdom. Next, I consider the people in my sphere of influence whom I hope to bring closer to God. Third, I go over the duties facing me: business trip, class preparations, laundry, dentist appointment, making cookies for the class party, etc. I now have in front of me three lists: Christians who need me; non-Christians I can influence; and this week's duties. These lists will change on a weekly basis; but they must be slotted into a schedule that has some structure already. Write down a seven-day schedule, filling in apportioned time for things that don't change: worship times, personal Bible study, work and other obligations. For the other items, priorities must be established. On another piece of paper, write down what is most important, then what is good, but not top priority, and finally, what is necessary sometime soon. This gives you three levels of tasks. Do the ones that are most important first, and don't make them contingent upon doing the ones of lesser importance. Regularly review what you have done to evaluate how it could have been done better.

Some planning tips are:

1. Check your schedule the night before, and set you mind on what's to be expected.
2. Get up early. Allow enough time for prayer time and a study of God's word.
3. Use "dead time" constructively. While showering or walking, make plans and pray that God's ideas will come into your mind.
4. Call ahead.
5. Be prepared. Keep enough gas in your car. Know where you are going.
6. Combine errands and appointments. Don't waste time.
7. Group activities by location.
8. Keep a calendar by the phone or in your purse.
9. Try to eliminate follow—up calls.
10. Double up time. Chaperoning my child's trip allows me to spend time with my children, exercise and meet adults in my community.
11. Unexpected time allows you to fill in chores.
12. Delegate some responsibilities and train others in what you have mastered.
13. Schedule times for fun, rest and meditation.
14. Avoid over-planning.

Putting it in to Practice

Spiritual priorities and wise planning are useless until they are put into practice. The road of good but unfulfilled intentions is paved by inconsistency, procrastination and laziness. To reach the goal of godly time management, you must make a firm decision to fight those sins by being consistent, dependable and energetic. Follow through on the commitments you make and do things on time without looking for ways to postpone responsibility. The command, *"Let your yes be yes and you no, no or you will be condemned"* (James 5:12), exemplifies how serious God

is about our reliability. Regard laziness as stealing time from God, and consider this scripture in Ephesians 4:28, *"He who has been stealing must steal no longer, but must work, doing something useful with his hands, that he may have something to share with those in need."*

Finally, keep in mind that we are trying to control our actions to be in harmony with his plan. Even the most disciplined life will be subject to unexpected schedule changes. Interruptions, however, need not distract us from our goal or cause us to lose our temper and efficiency. If we have the kind of relationship with God that enable us to depend upon him totally, then we can be confident that our dinner guests will be served on time even though a friend who is in desperate need of counsel calls us while we are getting the meal ready. Strive to be flexible.

Each new day is a precious gift from God, another opportunity to do his will. We can make the most of that gift by setting priorities that reflect Jesus as Lord and by planning before we begin, without allowing changes and interruptions to keep us from our goals. We need to remember that though we can prepare well, God will decide how events fall together. We should not question his wisdom because he knows the end of the story and is all powerful.

17

Hospitality Without Complaint

by Ann Lucas and Connie Mancini

Hospitality, the art of warmly sharing one's life and posses-
sions with others, is a theme that runs throughout God's word from
beginning to end. Numerous examples of hospitable people are
provided for us in the Bible, along with many commands to be
hospitable, such as Romans 12:13 and 1 Peter 4:9. God considers
hospitality so important that he has even made it a qualification
for leadership as an elder in the Lord's church, 1Timothy 3:12.

Hospitality is a vital part of the Christian woman's charac-
ter, a quality that distinguishes her as someone who truly loves
God. And it is not limited to the married woman's domain. Many
of the Biblical examples of hospitality show single women wel-
coming guests and offering their homes and resources gracious-
ly, with open arms. In view of that importance, we will examine
the purposes, principles, and rewards of hospitality to make it a
deeper part of our lives.

Purposes of Hospitality

Acts 16 records the conversion of Lydia, a wealthy busi-
nesswoman who, after her baptism, immediately invited Paul

and his companions to her home. *"If you consider me a believer in the Lord,"* she said, *"come and stay at my house."* Apparently, Lydia considered hospitality a natural response to God's grace.

When we understand the kind of gracious and generous God that we have, it is only natural to want to become more like him in giving to and caring for other people. Hospitality shows God how much we appreciate what he has done for us. This gratitude is seen in the Philippian jailer who, after he and all his family were baptized, brought Paul and his companions "into his house and set a meal before them, and the whole family was filled with joy because they had come to believe in God" (Acts 16:34). Peter's mother-in-law demonstrated the same response to Jesus. Matthew 8:15 records that *"He touched her hand and the fever left her, and she got up and waited on him."*

Hospitality is also a human expression of God's nature, a way for us to become more Christ-like. It incorporates the qualities of self-denial, kindness, and generosity, focusing on others rather than self. Abraham's kindness and generosity, focusing on others rather than self. Abraham's wife Sarah is an example of this. Genesis 18 describes the time Abraham and Sarah entertained strangers who were messengers from God. On short notice, Sarah quickly made bread and supervised the preparation of a feast to meet the strangers' needs. It may be this occasion that is referred to in Hebrews 13:2—*"Do not forget to entertain strangers, for by doing so some people have entertained angels without knowing it."*

The beautiful Rebekah is another example of godly hospitality. In Genesis 24, she was chosen to be the wife of Isaac because she generously drew water for Abraham's servant and camels, then went on to offer food and lodging as well.

Fruitful evangelism is another purpose for practicing hospitality. The infant church epitomized this spirit as *"all the believers were together and had everything in common. Selling their possessions and goods, they gave to anyone as he had need.*

Every day they continued to meet together with glad and sincere hearts, praising God and enjoying the favor of all the people. And the Lord added to their number daily those who were being saved" (Acts 2:44–47).

One result of that kind of hospitality was that *"the Lord added to their number daily."* We will experience the same result today as we share *"not only the gospel but our lives as well,"* 1Thessalonians 2:8. Bringing non-Christians into our homes for a meal is a natural and effective way to show them the love of God by our example of unselfish generosity and the loving relationships between roommates or family members.

Lastly, Jesus equated our hospitality toward others to our treatment of him personally when he said, *"I tell you the truth, whatever you did for one of the least of these brothers of mine, you did for me"* (Matthew 25:31-46). The fact takes us far beyond examples and commands of hospitality into the substance of our love for Jesus Christ and our fellow human beings. What could be more fulfilling for a Christian than to know she is truly serving Jesus personally? When we extend hospitality, we experience that holy honor.

Principles of Hospitality

It is of utmost importance that the hospitality which we offer be accompanied by the right attitude. God's word teaches us that thankfulness should be a dominant part of the Christian's character, Colossians 2:6–7. As we become more grateful for what we have, then sharing will become a natural desire. A heart *"overflowing with thankfulness"* will have no room for the complaining and grumbling that sometimes lies beneath our acts of hospitality. If sharing with others is something you do grudgingly, then it is time to examine your heart to see if you truly appreciate all that you have been given.

Pride is another wrong attitude that can keep us from being hospitable. People often fail to open their homes or share a meal

with others because they feel inadequate in some way, that their home is not nice enough or the food is too simple. We need to recognize those excuses for what they really are-pride and self-ishness-and get busy receiving the blessings God is waiting to heap upon us when we forget ourselves, trust him for the resources and make the most of what we have.

Jesus also stressed the importance of having the right motivation in showing hospitality. In Luke 14:12, he said, *"When you give a luncheon or dinner, do not invite your friends, your brothers or relatives or you rich neighbors; if you do, they may invite you back and so you will be repaid."* Jesus here illustrates the point that our hospitality should never depend on what we might get in return. That attitude can be very subtle. Our motives may be impure even if we are not consciously aware that they are so. A good way to test your motivation is to ask yourself: Who do I serve and show hospitality toward? Do I serve only certain kinds of people? Am I looking for any type of repayment or recognition?

Jesus concluded his lesson in Luke 14 by saying, *"But when you give a banquet, invite the poor, the crippled, the lame, the blind, and you will be blessed. Although they cannot repay you, you will be repaid at the resurrection of the righteous."* We need to be sure that our hospitality does not become an instrument of self service by limiting it to only those situations from which we stand to gain a recompense.

To develop a hospitable spirit, we need to cultivate the attitude of being others centered. That begins with making the decision to focus on others and how we can meet their needs. Once this decision is firmly established, we are certain to experience growth in our hospitality. Matthew 25:35–36 teaches that once a need is identified, the way to meet that need becomes obvious.

Hospitality must then be put in the proper perspective, as taught in the story of Mary and Martha, Luke 10:38–42. Martha loved the Lord with all her heart, but she allowed herself to

become "distracted by all the preparations that had to be made." Mary, on the other hand, kept her eyes on Christ and is remembered as the one who chose what is better. We must never become so encumbered with the details of serving that we forget the Lord and the people we are serving. Our joy comes not from impressing others but from sharing ourselves and all that God has given us with others. In this way we bring glory to God.

The scriptures are filled with practical suggestions of how we can become hospitable people. *"Therefore, as we have opportunity, let us do good to all people, especially to those who belong to the family of believers"* (Galatians 6:10). Let us dedicate our hearts to searching for opportunities to extend hospitality to the world around us. May God show us how to share His love with others, joyfully.

Rewards of Hospitality

It is truly sad when we look upon sharing with others as a Christian duty and do not realize that, as with all of God's commands, hospitality will go beyond meeting the needs of others and will bring the deepest joy and satisfaction to our own lives. Hospitable families repeatedly experience the reality of God giving back to them a hundred times as much as they have given.

The widow of Zarephath in 1 Kings 17:8–24 is an example of the way God blesses the hospitable. Even though she had so little food that she had resigned herself and her son to death from starvation, she was willing to share what she had with Elijah the prophet. God honored her hospitality by blessing her with all that she needed so that "there was food every day for Elijah and for the woman and her family.

The Shunammite woman in 2 Kings 4:8–37 is another who learned the lesson of *"Give and it will be given to you. A good measure, pressed down, shaken together, and running over will be poured into your lap. For the measure you use, it will be measured to you"* (Luke 6:38). **We cannot out-give God!**

Christian hospitality will also promote deeper unity within a congregation. Try adding a few brothers and sisters you don't know well to your next guest list of personal friends. Coming together in homes is a relaxing way for members not ordinarily in contact to get to know and appreciate one another.

Our hospitality, or lack of it, will be obvious to God. Jesus stressed the importance of this area of our lives and warned it could make the difference in where we spend eternity, Matthew 25:31–46. He also showed the simplicity of fulfilling this responsibility, the art of meeting the basic need of those around us. We must remain alert and aware of those needs and not allow ourselves o slip into a state of apathetic blindness. Then we will experience the joy of loving other people with all that we have and all that we are.

18

Preparing for Mission Work

Irene Gurganus

World evangelism is a reality in our lifetime! Mission teams are literally taking the gospel into all the world as Christ commanded in Matthew 28. Christians are answering the Upward Call to win souls in our land and other lands. Jesus Christ is the same yesterday, today and forever, Hebrews 13:8. God's word applies to all of mankind. It doesn't change. However, languages are different. Cultures are different. We have a bit to learn. His power is sufficient to teach us. The question is "are we willing"?

The person that answers YES, I am willing needs to consider three things:

1. Head training

2. Heart training

3. Habit training

Head Training

Foreign mission work is not an undertaking for the faithless dreamer. The work requires sharp, well-trained minds. It requires faith and God's power to meet the challenges of another culture. A

willingness to learn from others is a prerequisite. Remember, God is able, and you can't outgive him. A study of the country's history will help you relate to friends of another land. A firm foundation in God's word is essential. Paul says in Acts 22:3, that *"Under Gamaliel I was thoroughly trained in the law of our fathers."* All Christin evangelists should heed Paul's advice to Timothy and become workman that know God's word so well, they are never ashamed or unable to share it, 2 Timothy 2:15. Remember, God's word is designed for every culture and country. It applies to humankind worldwide. Keep in mind that citizens in many lands have never heard of the Bible, Jesus Christ or the God of Abraham, Isaac and Jacob.

Remember, two principles. First, the greatest preparation for seeking and saving the lost in another country is that you have had success in your native land. Second, learn from other disciples that have gone ahead of you, whatever country they were successful in. Learning from others is a principal of our Lord. He taught the 12 apostles and others about our Father.

A successful missionary will need the sensitivity that Paul exhibited in his teaching of the Athenian Greeks on Mars Hiss, Acts 17:16–34. Paul knew how to relate spiritual truths to people in a way they could understand, within the framework of their culture. That skill requires study. We need God's power and his word and knowledge of the culture. Many missionaries tend to not understand where others are coming from. We need prayer and study to do that. Also, be careful that you don't share the word from a perspective of your own biases and suppositions about the Bible's meaning which are culturally biased from your native country.

Heart Training

To be an effective missionary in another land, one must know Christ on more than an intellectual basis. The heart, soul and mind must be trained and in tune with Jesus. We must have a faith and emotional bond to Christ backed by a 100% commitment.

Jesus said that the two greatest commandments are to love God and to love our neighbor, Matthew 22:37–39). The second commandment is possible only when the first is accomplished and growing. No one should consider being involved in foreign missions who is not totally committed to God and sharing a close personal relationship with him. Paul became *"all things to all men"* so that he might save some, 1 Corinthians 9:19–22. However, Paul was bilingual, able to speak and identify with both Greeks, Hebrews (Jews) and others. Many disciples are monolingual. To be effective, a cross-cultural ambassador for Christ must learn to free themselves from racial or national pride and follow Paul's admonition to see things from another's point of view, Philippians 2:4. The natural tendency of mankind is to be prideful, self-centered, and group-centered, thus isolating themselves from people of different cultures. Such attitudes of personal or national superiority are barriers to the unity of mankind which God desires. True surrender and prayer will allow the Lord to train your heart and eliminate this barrier to effectiveness.

Paul became *"all things to all men"* so that he might save some, 1 Corinthians 9:19–22. Becoming, like people of another land involves identifying with those people, learning their language and their culture. This takes head and heart training as well as prayer and the power of God. Cultural identification takes time. Too often, people get discouraged too soon to learn. Pray that you have the faith that will allow you to persevere as you learn. God will bless you. God will work in your heart and humble you so that you can truly identify with the people that want to find our Lord.

Habit Training

The goal of the disciple of Christ is to imitate his life, Matthew 5:48. Paul understood this growth process: *"Not that I have already obtained all this or have already been made perfect, but I press on to take hold of that for which Christ Jesus took hold of*

me. Brothers, I do not consider myself yet to have taken hold of it. But one thing I do: Forgetting what is behind and straining toward what is ahead, I press on toward the goal to win the prize for which God has called me heavenward in Christ Jesus" (Philippians 3:12–16).

That attitude will help us in forming the habit of thinking and behaving like Christ. As disciples, we must go beyond being students and adopt the lifestyle and mindset of our Master. Spiritual growth depends on putting into practice what we have learned and trying to keep on learning. When George and I went to Japan we were young and had a lot of learning to do. We had to learn the language and the culture. God strengthen us, day by day. We helped others become disciples of Christ.

Habit formation allows us to let our light shine and teach those that become disciples to imitate our lives from the heart. The disciple provides a Christlike example for new disciples to follow. We must continually and prayerfully examine our lives to see if we are growing in our Christlikeness, so that we can teach others how to do the same. Can you like Paul in 1 Corinthians 11:1, call others to follow your example as you follow the example of Christ?

Some practical pointers are helpful if you are considering being a missionary.

- If you are going to work in a land with a different language. Do you know the language? Do you have a gift for language? If not, try to begin learning it prior to your departure.

- Are you flexible in your habits? What is your attitude toward food, for example?

- Are you healthy? Do you suffer with allergies? How often do you see a physician? Will your health allow you to live in the country you are going to?

- Can you refrain from defending your rights, 1 Corinthians 8:9–11?

- Do you know the difference between necessities and luxuries? Are you content with the minimum? Many necessities are luxuries in the rest of the world.

Jesus was a fisher of men, and he taught his disciples to do likewise, Matthew 4:19. Timothy, Titus and others learned how to be effective fisher of men from Paul as they traveled with him on his missionary journeys. We must do the same, John 15:9. Do you and others describe you as a fisherwoman?

Preparation to work for God in another land, is unique. It is not glamorous or easy, however it is rewarding. It requires a thorough knowledge of the Bible, the language, and the culture to which one is going and most importantly faith and prayer that God will work through you. You must have an ability to win souls to Christ and disciple them to spiritual maturity. May God be with you as you prepare to take the precious gospel to people of every nation. Without you and others like you many will not find our Lord and be with us for eternity.

References:

Gurganus, George. *Guidelines for World Evangelism.* Biblical Research Press, Abilene, TX. Hardin, Joyce. *Sojourner* (Published in Korea). Lubbock Christian College, Lubbock, TX. Hile, Pat. Physical Identification, Harding Graduate School of Religion, Memphis, TN.

2022 addendum.

George and Irene Gurganus were some of our best friends. They lived with us for months and intermittently. I worked with George, Irene and Frank Kim (a

student at Harvard University at the time) for 9 months in Boston. It was a wonderful and enlightening experience. They practiced what they preached. They were missionaries in Japan after World War II for many years and went back to Japan when the church was replanted in Tokyo. They spent their last years in the San Diego congregation and are with God now. God was glorified by their lives.

Conclusion

"Now to him who is able to do immeasurably more than all we ask or imagine, according to his power that is at work within us, to him be glory in the church and in Christ Jesus through all generations for ever and ever! Amen."

We all know that the Bible is relevant to our lives. It is timeless and allows us to know how to live for God in any situation and at any time. It is not specific to any country, race, culture, or sex. We can all learn to live and be blessed by God in this life and for eternity. Perfect love is our example. Any woman who has God's power at work withing her can do unimaginable things for Him. To do so, we must daily decide to make Jesus Lord of our lives and pray for God to lead us. Each chapter of *The Upward Call* is based on the Word of God, it is personal, an outpouring of a woman's life who has decided to respond to the upward call of God and allow him to use her in his service. Like Paul teaches, none of us will ever reach perfection on earth, we can only forget what lies behind us, strain toward what lies ahead of us and continue to *"press on toward the goal for the prize of the upward call of God in Christ Jesus"* Philippians 3:12–14. Only when we finally reach heaven, will we truly have rest from daily battles with Satan. Satan doesn't want us to purify our lives and to help others find God and eternity with Christ and the Holy Spirit.

Prayerfully, this book has touched your heart and inspired you to live a God filled, righteous life. You may have identified with some of the struggles and victories described in these pages. Paul, a great teacher and example, urged the Philippians to listen to his words, examine his life, and change their lives accordingly. *"Whatever you have learned or received or heard from me or seen in me-put into practice. And the God of peace will be with you"* (Philippians 4:9).

Please consider what you have learned and received from reading these chapters, and what you have seen in the women who have shared their lives with you. Put into practice that which you believe to be Christ-like and of God. And most importantly, continue to grow and mature in your own life through prayer, study of the word, counsel from other Christians, and with the Holy Spirits help, strive toward what lies ahead. Then the God of peace will be with you, always.

I just said a prayer for you to grow. Please pray for me as well. I love you, but God loves you more. He is our source of love and peace. Christ is our example. His love inspires me daily.

In Christ, you humble servant,

—Pat Gempel

You Can Help Others Grow

If you want to help by ordering additional copies of this book from Illumination Publishers for $14.99, we will donate $4.00 for every book to either:

- *HOPE for Kids.* https//hope for kids.org or
- Chance Of A Lifetime (COAL), a program of the Beam Missions Foundation. https://beam missions.org.

You can help kids whose parents are financially challenged to attend Camp or you can help recent college graduates participate in a 15–month program of service to others at Camp Hope for Kids, in Boston and outside the U.S.

Order at www.ipibooks.com